TRADING STYLE

WELTKULTUREN
MUSEUM

TRADING STYLE

EDITED BY / HERAUSGEGEBEN VON
CLÉMENTINE DELISS & TEIMAZ SHAHVERDI
FRANKFURT AM MAIN

KERBER FORUM

6 – 13
A TRADING POST FOR
GLOBAL STYLE AND FASHION
CLÉMENTINE DELISS

14 – 19
EINE HANDELSSTATION FÜR
GLOBALE STILE UND MODEN
CLÉMENTINE DELISS

20 – 95
GLOBAL STYLE

96 – 183
COLLECTION

184 – 249
COLLECTION
OF THE COLLECTION

186 – 189
ACCELERATED FASHION
TEIMAZ SHAHVERDI

190 – 203
BUKI AKIB

204 – 217
A KIND OF GUISE

218 – 231
CASSETTEPLAYA

232 – 249
P.A.M.

250 – 253
BIOGRAPHIES

254 – 262
INDEX

264
IMPRINT

A TRADING POST FOR GLOBAL STYLE AND FASHION

A TRADING POST
FOR GLOBAL STYLE AND FASHION

At the Weltkulturen Museum in Frankfurt, we reconnect historic ethnographic artefacts to contemporary practices. Combining anthropology with art and fashion, we perceive the objects in the museum's collection as prime source material for new knowledge production intended for both a specialist audience and a broader public. Our first exhibition and publication, "Object Atlas – Fieldwork in the Museum" engaged visual artists in this dialogical experiment.[1] With "Trading Style", the museum's collection is viewed through the eyes of a new generation of fashion and lifestyle labels from Australia, Nigeria, Germany and the United Kingdom. Each has created designs based on the museum's extensive resource of images, films, and artefacts from around the world. This creative process took place on site at the Weltkulturen Museum during the course of 2012 and has resulted in the exhibition "Trading Style – Weltmode im Dialog" and in this publication.

Fashion today is increasingly characterised by a global industry connected to trans-continental outsourcing, uncontested monopolies of high-street chain stores, ubiquitous design styles, and the consumption of disposable, low-to-high price material goods. The mainstream production of fashion, including established brands or houses, requires of designers that they produce anything between four to eight collections per year per label. Regardless of this pressure, designers are confronted with a slow-moving system reliant on the bedfellows of publishing and advertising, corporate marketing and long-term planning, all of which stultifies fashion's system of signs, its sensibility for the unforeseeable, and its ability to create, exchange and communicate different identities.

Selected by Teimaz Shahverdi, initiator of the Frankfurt label Azita, the four international designers in "Trading Style" represent a new direction in fashion. A Kind of Guise, Buki Akib, CassettePlaya, and P.A.M. produce garments from sophisticated textiles, often manufacturing by hand in small workshops in Lagos, London, the north of England, Germany, Japan, India, Hong Kong or Argentina. Their cycle of production emphasises regional craftsmanship combined with high-tech design processes and luxury materials. Compared to the mass fabrication, distribution, and consumerism of clothing, their experimental approach embraces modes of lifestyle and artistic

collaboration. They represent a horizontal fashion landscape that emancipates itself from the Haute Couture of Paris, London, Milan or New York yet competes on equal footing when it comes to style and sensibility. Their definition of accessories extends beyond bags and belts normally associated with fashion to incorporate sound, video, photography, and more generally an approach to life understood as a "psychedelic workshop" (P.A.M.). Catwalk presentations are replaced by video productions, products are borne out of cooperations between artists, designers and musicians, and manufacturing is reduced to a manageable and ethical scale. These designers embody a concept of fashion that circulates under the radar of high-street trends and corresponds to a cross-border, cross-label attitude with an independent speed of decision-making. Indeed, their DIY approach to business is not unlike a black market in sub-cultural style that cruises the physical streets of cities and connects via the digital highways. Sales are no longer reduced to a one-brand boutique that strives towards the flagship store of mainstream designers. Instead these labels operate through virtual micro-emporia, offering goods online from a family of like-minded brands.

Usually working from Munich, Lagos, London and Melbourne, for "Trading Style" each designer travelled to Frankfurt and lived and worked for several weeks in the Weltkulturen Labor, a new facility adjacent to the museum, which houses lab spaces, project rooms, artist studios and guest apartments. At the start of their residency, they spent time in the vast stores of the museum negotiating a selection of objects with the restorers and research curators, each specialised in the ethnography and material culture of different regions ranging from the Americas through to Africa, South-East Asia and Oceania. In addition, the museum's image archive proved particularly rich in reference material revealing hundreds of photographs and films that not only make powerful statements on style and fashion, but act as recordings of clothing production and body adornment from different parts of the world. With the creative experience of Teimaz Shahverdi and the scholarly engagement of the museum's anthropologists, this dialogue led to new productions of prototype garments, accessories and jewellery directly referencing the Weltkulturen Museum's collection.

During the residencies, studios at the museum were transformed into workshop environments and sewing machines, ironing boards, tools for making batik and even a ceramic kiln provided the technical means for testing out

new materials and shapes. The walls of workspaces were invariably covered with collages of images from the museum's archive and reference books from the library lined the tables. Computer programmes digitised motifs and translated ideas into technical plans for future clothing. In the lab rooms of the museum, selected artefacts from the collection were made available for professional research. These ranged from entire body disguises, masks, tops, trousers, shoes, bags, feather headdresses, jewellery and textiles but also other objects not necessarily connected to fashion, such as musical instruments.

Most of the designers worked in teams. The first to arrive in March 2012 were A Kind of Guise from Munich, who came to Frankfurt with six collaborators. They focused on Mexican, Indonesian, and Melanesian cultures selecting a heterogeneous group of artefacts including soap packaging, theatrical masks, knitted body costumes used in children's naming ceremonies in New Guinea, plus a variety of hand-loomed and printed textiles. Buki Akib from Lagos and London chose musical instruments such as drums, gongs and thumb pianos thereby extending her interest in fashion and music that she had begun with "FELA", her degree show for Central St. Martins College of Art and Design in London in 2010. Tapping into the synaesthetic quality of the museum's collection, she developed new knits and weaves based on the texture and structure of instruments some of which, like sonic jewellery, are worn on the body as shakers or rattles. Carri Munden from London, known under the label CassettePlaya, focused specifically on tattooing and scarification from Melanesia and the Brazilian Amazon region. Picking out elaborate bridal headdresses, feather necklaces, an extraordinary rucksack from the Philippines as well as other unusual artefacts, she derived digital prints on silk, a new micro-collection of luxury street-wear, and collaborated with London-based designers Duffy and Charlie le Mindu. Her video "Blood Rites", produced as an alternative medium to a catwalk show and transmitted online as well as at the Paris and London fashion weeks, mixes a documentary film by German traveller and anthropologist Hermann Schlenker of a scarification ritual in New Guinea in the 1970s with tattooing and youth swagger in Britain today. The designer duo P.A.M. from Melbourne combined photographs from the image bank of the museum with Mayan symbols and folk iconography. Working on paper, cotton and silk they generated a series of prints that directly reference their understanding of "global tribes", a montage of people, architecture, landscape and objects of everyday use. In addition, P.A.M. high-

light the unusual cuts of garments found in the ethnographic collection and transform West African men's pants with oversize gathering around the waist into a new trouser shape for their summer collection 2013.

For "Trading Style", the museum's unusual context of production with its extensive stores, in-house lab, library, image archive and research expertise proves beyond doubt that there is significant creative potential to be had in re-working older artefacts into contemporary designs. Materials, techniques and styles of the past are reconfigured within today's globalised urban context. Folklore and traditional clothing become part of a 21st century idiom that rearticulates tensions between uniformity and eccentricity, group identity and individual taste. Underlying the formal resonance between past and present is an interest on the part of all four designers in local creative industries worldwide and the regeneration of non-industrial modes of production.

This publication is divided into three parts. The first, "Global Style" combines historical photographs from the archive of the museum with images taken from recent look books or style sheets of the four guest fashion labels. The dialogue that takes place here is astonishing: each double page of photographs displays correspondences in clothing, pose and attitude. The contemporary designers are smuggled into the sequence, breaking down the hierarchy that may seem to exist between cultures, periods and fashions.

The second section "Collection" presents an engaging insight into the Weltkulturen Museum's ethnographic collection with a focus on accessories including moccasins from North America, net bags from New Guinea, a variety of combs from West Africa plus a myriad of jewellery, aprons, sandals, shoes and hats. The selection of artefacts spans street styles of the world through to ceremonial dress and includes exotic Black Forest glass wedding crowns from Germany, the only objects on loan to the exhibition that are not part of the collection. Each item conveys exquisite craftsmanship and innovation. From pouches decorated with dogteeth, filigree nail extensions made of paper-thin brass, rainbow-coloured feather headdresses or eccentric wigs, the assemblage of fashion items from the Weltkulturen Museum offers a remarkable insight into a wide variety of unique designs, patterns, colour codes and manufacturing techniques.

The final chapter of this publication, "Collection of the Collection" shows the laboratory environment of each of the designers as they lived and worked in residency at the Weltkulturen Museum. The new prototypes that

emerged through their time at the museum represent the very first stages of an interdisciplinary dialogue that continues to ignite the imagination and feed into future designs. The juxtaposition of photographs, objects, and working situations in this publication throws up many questions. How is it that people from different cultures and generations communicate so efficiently through clothing and why does style have so much currency on global streets, forming individual identities and trading a sense of presence?

The exhibition and publication "Trading Style" is part of Theatrum Mundi/Global Street, a long-term investigation spear-headed by Richard Sennett and Saskia Sassen with partners in Frankfurt, New York and London. With the overall concept of "Trading Perceptions", the museum highlights people's different awareness of the city as an urban stage with its streets and networks, theatre of objects and systems of exchange. It becomes a dynamic trading post for understanding the world through material culture, past and future.

I would like to thank Teimaz Shahverdi for his engagement with the Weltkulturen Museum and his interest in developing "Trading Style" as an exhibition and publication, Christine Peters for coordinating the project so efficiently and helping us to crossover between ethnography, fashion and performance, Mathis Esterhazy for developing the installation design and vitrines, and Nina Huber for her exacting curatorial organisation and enthusiasm. Moreover, my thanks go to the research curators and restorers of the Weltkulturen Museum whose commitment to remediating the artefacts and introducing new contexts of analysis and interpretation has enabled us all at the museum to sense the energy of the collection and to try to find ways to pass on this exceptional cultural heritage to future generations.

[1] GUEST ARTISTS INCLUDED HELKE BAYRLE, THOMAS BAYRLE, MARC CAMILLE CHAIMOWICZ, SUNAH CHOI, ANTJE MAJEWSKI, OTOBONG NKANGA, AND SIMON POPPER ALL OF WHOM PRODUCED NEW WORK IN THE WELTKULTUREN MUSEUM'S LAB BASED ON THEIR SELECTIONS FROM THE ARCHIVES. THE HISTORICAL ANTECEDENT WAS PROVIDED BY ALF BAYRLE, EXPEDITION PAINTER FOR THE FRANKFURT MUSEUM IN THE 1930S, AND THE QUMRAN VERLAG FÜR ETHNOLGIE UND KUNST ESTABLISHED BY HANS-JÜRGEN HEINRICHS IN THE 1980S. SEE "OBJECT ATLAS – FIELDWORK IN THE MUSEUM", EDITED BY CLÉMENTINE DELISS, KERBER VERLAG, 2012.

EINE HANDELSSTATION
FÜR GLOBALE STILE UND MODEN

Im Weltkulturen Museum in Frankfurt bringen wir erneut historische ethnografische Artefakte mit zeitgenössischen Arbeitsweisen zusammen. In der Verbindung von Anthropologie, Gegenwartskunst und Mode begreifen wir die Exponate der Museumssammlung als Quellenmaterial für neue Wissensinhalte, sowohl für ein Fachpublikum als auch für eine breitere Öffentlichkeit. Bereits für unsere erste Ausstellung und Publikation „Objekt Atlas – Feldforschung im Museum" wurden bildende Künstler in dieses dialogische Experiment eingebunden.[1] Mit „Trading Style" betrachten wir die Museumssammlung durch die Augen einer neuen Generation von Mode- und Lifestyle-Labels aus Australien, Nigeria, Deutschland und Großbritannien. Die Designer haben auf der Basis der umfangreichen musealen Ressourcen von Bildern, Filmen und Artefakten aus der ganzen Welt ihre eigenen Entwürfe entwickelt. Dieser kreative Prozess hat 2012 vor Ort im Weltkulturen Museum stattgefunden und mündete schließlich in die Ausstellung „Trading Style – Weltmode im Dialog" sowie in diese Publikation.

Mode ist heutzutage zunehmend durch eine globale Industrie des transkontinentalen Outsourcings gekennzeichnet sowie durch die unangefochtenen Monopolstellungen der üblichen Einzelhandelsketten, durch omnipräsente Designstile und den Konsum wegwerfbarer Billigprodukte bis zu dem hochpreisiger Luxusgüter. Die Massenproduktion der Mode, auch die der etablierten Marken, fordert den Designern vier bis acht Kollektionen pro Jahr pro Label ab. Abgesehen von dem Druck, der auf den Designern lastet, sehen sich diese zusätzlich mit einem schwerfälligen System konfrontiert, das auf Anzeigen und Werbung, Corporate Marketing und langfristiger Planung beruht, was das semiotische Sytem der Mode, ihre Sensibilität für das Unvorhersehbare und damit ihre Fähigkeit, verschiedene Identitäten zu schaffen, auszutauschen und diese zu kommunizieren, unterläuft.

Die vier internationalen Designer von „Trading Style", die Teimaz Shahverdi, Initiator des Frankfurter Labels Azita, ausgewählt hat, repräsentieren eine neue Richtung in der Mode. A Kind of Guise, Buki Akib, Cassette-Playa sowie P.A.M. produzieren Kleidung aus raffinierten Textilien, die häufig in kleinen Produktionsbetrieben in Lagos, London, Nordengland, Deutschland, Japan, Indien, Hongkong oder Argentinien in Handarbeit hergestellt

werden. Ihre Produktionszyklen beruhen auf regionalem handwerklichem Wissen und Können, in Verbindung mit Hitech-Designprozessen und Luxusmaterialien. Im Vergleich zu Massenproduktion, -vertrieb und -konsum von Bekleidung schließen sie mit ihrer experimentellen Herangehensweise auch verschiedene Formen des Lifestyles und der künstlerischen Kollaboration ein. Sie repräsentieren eine horizontale Modelandschaft, die sich von der Haute Couture in Paris, London, Mailand oder New York emanzipiert, aber hinsichtlich Stil und Sensibilität auf gleicher Augenhöhe konkurriert. Ihre Definition von Accessoires geht über die üblichen Taschen und Gürtel hinaus und umfasst unter anderem Sound, Video und Fotografie beziehungsweise definiert sich als Lebensphilosophie oder, wie P.A.M. sagen würden, als „psychedelischer Workshop". Laufstegpräsentationen werden durch Videoproduktionen ersetzt, die Produkte entstehen in der Zusammenarbeit zwischen Künstlern, Designern und Musikern, und die Herstellung wird auf ein handhabbares und ökologisch vertretbares Maß beschränkt. Diese Designer verkörpern ein Modekonzept, das unter dem Radar der herrschenden Einzelhandelsketten und ihrer Trends zirkuliert: ihre grenzüberschreitende Haltung zeichnet sich durch ein individuelles Tempo der Entscheidungsfindung aus. Ihr Do-It-Yourself-Businessmodell ähnelt durchaus dem Schwarzmarkt subkultureller Stile, der sich auf den Straßen der Städte abspielt und über die digitalen Highways vernetzt wird. Verkäufe sind nicht mehr auf Läden beschränkt, die einer Marke vorbehalten sind und den Flagshipstores des Mainstreams nacheifern. Stattdessen agieren diese Designer auf der Basis virtueller Mikro-Läden und vertreiben die Produkte gleichgesinnter Labels online.

Normalerweise in München, Lagos, London oder Melbourne zu Hause, haben die bei „Trading Style" mitwirkenden Designer mehrere Wochen im Weltkulturen Labor in Frankfurt gelebt und gearbeitet. Das Weltkulturen Labor ist eine neue Einrichtung neben dem Museum, in der sich Forschungs- und Projekträume sowie Künstlerateliers und Gästewohnungen befinden. Zu Beginn ihres Aufenthalts verbrachten sie zunächst einige Zeit mit den umfangreichen Sammlungsbeständen des Museums, berieten sich mit Restauratoren und Forschungskustoden, die auf Ethnografie und die Materialkultur unterschiedlicher Weltregionen spezialisiert sind, von Amerika und Afrika bis zu Südostasien und Ozeanien, und wählten dann eine Anzahl von Objekten aus, mit denen sie arbeiteten. Überdies bot das Bildarchiv des Museums einen außerordentlich reichen Fundus an Referenzmaterial: Unzählige Fotografien

und Filme lieferten nicht nur substantielle Kommentare zu Stil und Mode, sondern sind auch nach wie vor Dokumentationen der Kleidungsherstellung und Körperverzierung aus allen Teilen der Welt. Mit der kreativen Erfahrung von Teimaz Shahverdi und der wissenschaftlichen Unterstützung der Museumsethnologen, führte dieser Dialog zur Produktion neuer Prototypen von Kleidung, Accessoires und Schmuck, die unmittelbar auf die Sammlung des Weltkulturen Museums Bezug nehmen.

Während des Aufenthalts der Designer wurden die Ateliers des Museums zu Werkstätten, in denen Nähmaschinen, Bügelbrett, Batikutensilien und sogar ein Keramikbrennofen die technischen Voraussetzungen lieferten, um neue Materialien und Formen auszutesten. Die Wände der Arbeitsräume waren über und über mit Collagen der Bilder aus dem Bildarchiv des Museums bedeckt, während auf den Tischen stapelweise Nachschlagewerke aus der Bibliothek lagen. Mit Computerprogrammen wurden Motive digitalisiert und Ideen in technische Pläne für zukünftige Kleidungsstücke übertragen. In den Laborräumen des Museums standen ausgewählte Exponate aus der Sammlung zur wissenschaftlichen und künstlerischen Erforschung zur Verfügung, wie zum Beispiel Ganzkörperbekleidung, Masken, Oberteile, Hosen, Schuhe, Taschen, Federkopfbedeckungen, Schmuck, Textilien, aber auch Objekte, die nicht notwendigerweise mit Mode zu tun haben, wie Musikinstrumente.

Die meisten der Designer haben in Teams gearbeitet. Im Februar 2012 traf mit A Kind of Guise aus München das erste Team mit sechs Mitarbeitern ein. Sie legten den Schwerpunkt auf mexikanische, indonesische und melanesische Kulturen und wählten eine heterogene Gruppe von Artefakten aus – dazu zählten Seifenverpackungen, Theatermasken, gestrickte Kostüme, die für Namensgebungszeremonien in Neuguinea benutzt wurden, sowie eine Reihe verschiedener, von Hand gewebter und bedruckter Textilien. Buki Akib aus Lagos und London wählte Musikinstrumente wie Trommeln, Gongs und Daumenklaviere aus und erweiterte damit ihr Interesse für Mode und Musik, das 2010 mit „FELA", ihrer Diplomschau am Central St. Martins College of Art and Design in London, seinen Anfang genommen hatte. Mit der Erschließung der synästhetischen Qualitäten der Museumssammlung entwickelte sie neue Strick- und Webarten in Lagos, die auf der Textur und Beschaffenheit von Instrumenten beruhen, die wie akustischer Schmuck als Rasseln oder Klappern auf dem Körper getragen werden. Carri Munden aus London, die unter dem Label CassettePlaya bekannt ist, richtete ihre Aufmerksamkeit speziell auf Tätowie-

rungen und ornamentale Skarifizierungen aus Melanesien und der brasilianischen Amazonasregion. Auf der Basis ihrer Auswahl – dazu gehörten kunstvoller Brautkopfschmuck, Federhalsketten oder ein virtuos geflochtener Rucksack aus den Philippinen – entwickelte sie digitale Drucke auf Seide, eine neue Mikrokollektion luxuriöser Streetwear und arbeitete mit den in London ansässigen Designern Duffy und Nasir Mazhar zusammen. Ausgehend von einem zentralen Thema ihrer Arbeit – der Beobachtung und Übersetzung männlicher Initiationsriten heute – produzierte sie das Video „Blood Rites" als alternatives Medium zum Laufsteg, zeigte es online sowie während der Modewochen in Paris und London. Das Video besteht aus einem Mix von dokumentarischen Zitaten aus Filmen des deutschen Reisenden und Ethnologen Hermann Schlenker aus den 1970er Jahren über ein Skarifizierungsritual in Neuguinea sowie Tätowierungen als Ausdruck männlicher Jugendkultur im Großbritannien von heute.

Das Designerduo P.A.M. aus Melbourne arbeitete mit Papier, Baumwolle und Seide, collagierte Fotos aus dem Bildarchiv des Museums mit Mayasymbolen und Volksikonografie und entwarf mit einer Serie von Drucken sein Verständis von „global tribe": als eine Montage von Menschen, Architektur, Landschaft und Alltagsobjekten. Darüber hinaus übersetzten sie ausgefallene Kleidungsstücke der Sammlung, wie z. B. westafrikanische Männerhosen mit übergroßer Taille, in eine neue Hosenform für ihre Sommerkollektion 2013.

„Trading Style" zeigt, wie die ungewöhnliche Produktionsumgebung des Museums mit seinen Sammlungsbeständen, dem Labor, der Bibliothek, dem Bildarchiv und der umfangreichen Forschungskompetenz ein bedeutendes kreatives Potenzial eröffnen kann, um historische Artefakte in zeitgenössisches Design zu übersetzen. Materialien, Techniken und Stilformen der Vergangenheit werden im aktuellen globalen Kontext neu interpretiert. Trachten und traditionelle Bekleidung werden Teil einer Ausdrucksform des 21. Jahrhunderts, die das Spannungsverhältnis zwischen Uniformität und Exzentrik, Gruppenidentität und individuellem Geschmack re-formuliert. Die Arbeit der vier Designer beruht auf der formalen Resonanz zwischen Vergangenheit und Gegenwart, auf ihrer Zusammenarbeit mit ihren jeweiligen kleinen Manufakturen sowie der Neubelebung von Handwerk und anderen nicht industriellen Produktionsformen.

Die Publikation ist in drei Teile gegliedert. Im ersten Teil „Global Style" finden sich historische Fotografien aus dem Museumsarchiv sowie Bilder aus den aktuellen Lookbooks und Stylesheets der vier eingeladenen Modelabels.

Der Dialog, der sich hier entwickelt, ist erstaunlich: Jede Fotodoppelseite zeigt Entsprechungen in Kleidung, Pose und Haltung. Die Arbeiten der zeitgenössischen Designer wurden diskret unter die anderen Bilder gemischt, als ob sie die Hierarchie zwischen Kulturen, Zeitabschnitten und Moden aufheben würden.

Der zweite Teil „Collection" präsentiert einen umfassenden Einblick in die ethnografische Sammlung des Weltkulturen Museums. Der Schwerpunkt liegt dabei auf Accessoires: Mokassins aus Nordamerika, Häkeltaschen aus Neuguinea, Kämme aus Westafrika sowie zahlreiche Schmuckstücke, Schürzen, Sandalen, Schuhe und Hüte. Die Auswahl der Artefakte umfasst Streetwear aus der ganzen Welt, zeremonielle Kleider sowie exotische Hochzeitskronen aus Glas aus dem Schwarzwald – übrigens die einzige Leihgabe, die nicht Teil der Museumssammlung ist. Jedes Objekt zeichnet sich durch großes handwerkliches Geschick und Innovation aus: von Beuteln, die mit Hundezähnen verziert wurden, bis zu filigranen Nagelverlängerungen aus hauchdünnem Messing, regenbogenfarbigem Federkopfschmuck oder prächtigen Perücken. Diese wertvollen Stücke geben Auskunft über die große Vielfalt einzigartiger Gestaltungsformen, Muster, Farbsysteme und Herstellungstechniken.

Das abschließende Kapitel zeigt mit „Collection of the Collection" die Laborumgebung der jeweiligen Designer während ihres Aufenthalts und ihrer Arbeit vor Ort im Weltkulturen Museum. Die neuen Prototypen, die in den entsprechenden Zeitabschnitten im Museum entstanden sind, veranschaulichen die ersten Phasen eines interdisziplinären Dialogs, der sicherlich in zukünftige Designformen einfließen wird. Die Nebeneinanderstellung von Fotos, Objekten und Arbeitssituationen wirft viele Fragen auf: Warum kommunizieren Menschen aus verschiedenen Kulturen und Generationen auf so wirkungsvolle Weise durch Kleidung? Und wie kommt es, dass Stil auf den Straßen der globalen Welt so hoch gehandelt wird und dabei so hochgradig individuelle Identitäten herausbildet?

Die Ausstellung „Trading Style" mit ihrer begleitenden Publikation ist Teil eines mehrjährigen Forschungsprojekts, welches das Weltkulturen Museum in Zusammenarbeit mit Theatrum Mundi / Global Street – geleitet von Richard Sennett und Saskia Sassen und konzipiert mit Partnern in Frankfurt, New York und London – veranstaltet. Mit dem Konzept „Trading Perceptions – Wahrnehmungen verhandeln" stellt das Museum das unterschiedliche Bewusstsein der Menschen für die Stadt als urbane Bühne mit ihren Straßen

und Netzwerken, Objekttheatern und Tauschsystemen heraus. Das Museum wird zu einem dynamischen Handelsposten für das Verständnis der Welt über die materiellen Kulturen, die zwischen Vergangenheit und Zukunft liegen.

Ich möchte Teimaz Shahverdi für sein Engagement und sein Interesse danken, mit dem er „Trading Style" als Ausstellung und Publikation für das Weltkulturen Museum entwickelt hat, Christine Peters für die effiziente Koordination des Projekts und ihre Unterstützung, wenn es um das Crossover zwischen Ethnologie, Mode und Performance ging, Mathis Esterhazy für die Entwicklung der Installation und Vitrinen und Nina Huber für ihre präzise kuratorische Organisation und ihren Enthusiasmus. Überdies geht mein Dank an die Forschungskustodinnen und Restauratoren des Weltkulturen Museums, deren Bereitschaft, die Artefakte einer Neubetrachtung zu unterziehen und neue Kontexte der Analyse und Interpretation einzuführen, es allen Beteiligten im Museum ermöglicht hat, die Energie der Sammlung zu spüren und neue Wege zu finden, dieses besondere Kulturerbe an zukünftige Generationen weiterzugeben.

[1] ZU DEN EINGELADENEN KÜNSTLERN GEHÖREN HELKE BAYRLE, THOMAS BAYRLE, MARC CAMILLE CHAIMOWICZ, SUNAH CHOI, ANTJE MAJEWSKI, OTOBONG NKANGA UND SIMON POPPER; SIE ALLE SCHUFEN NEUE WERKE IM LABOR DES WELTKULTUREN MUSEUMS AUFGRUND IHRER JEWEILIGEN AUSWAHL AUS DEN ARCHIVBESTÄNDEN. DIE BEISPIELHAFTEN HISTORISCHEN BEZUGSPUNKTE BILDETEN ALF BAYRLE, DER ALS MALER BEI DEN FORSCHUNGS-REISEN DES MUSEUMS IN DEN 1930ER JAHREN TÄTIG WAR, UND DER QUMRAN VERLAG FÜR ETHNOLOGIE UND KUNST, DER IN DEN 1980ER JAHREN VON HANS-JÜRGEN HEINRICHS GEGRÜNDET WURDE. SIEHE „OBJEKT ATLAS – FELDFORSCHUNG IM MUSEUM", HRSG. CLÉMENTINE DELISS, KERBER VERLAG, 2012.

GLO
BAL
STYLE

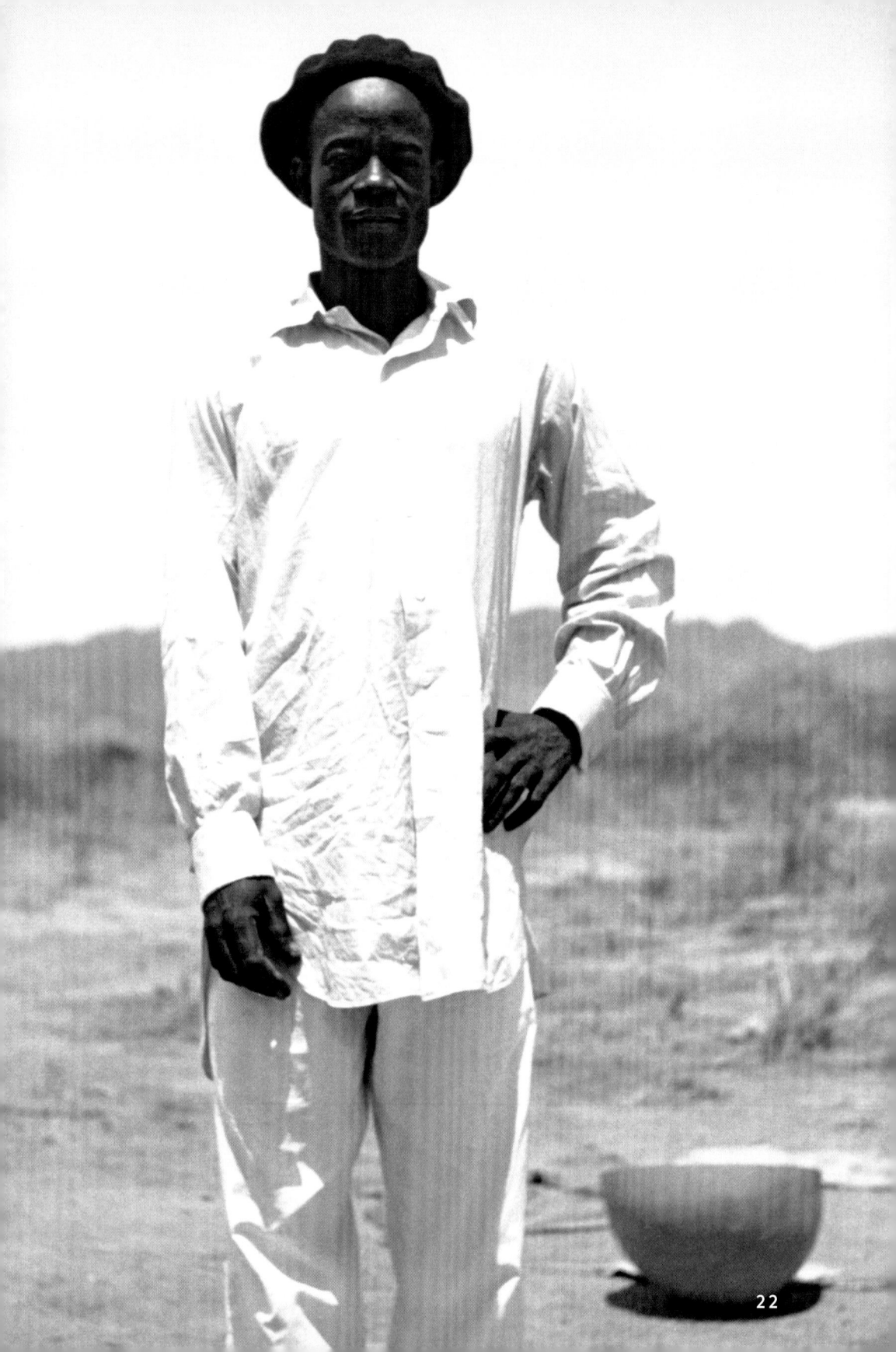

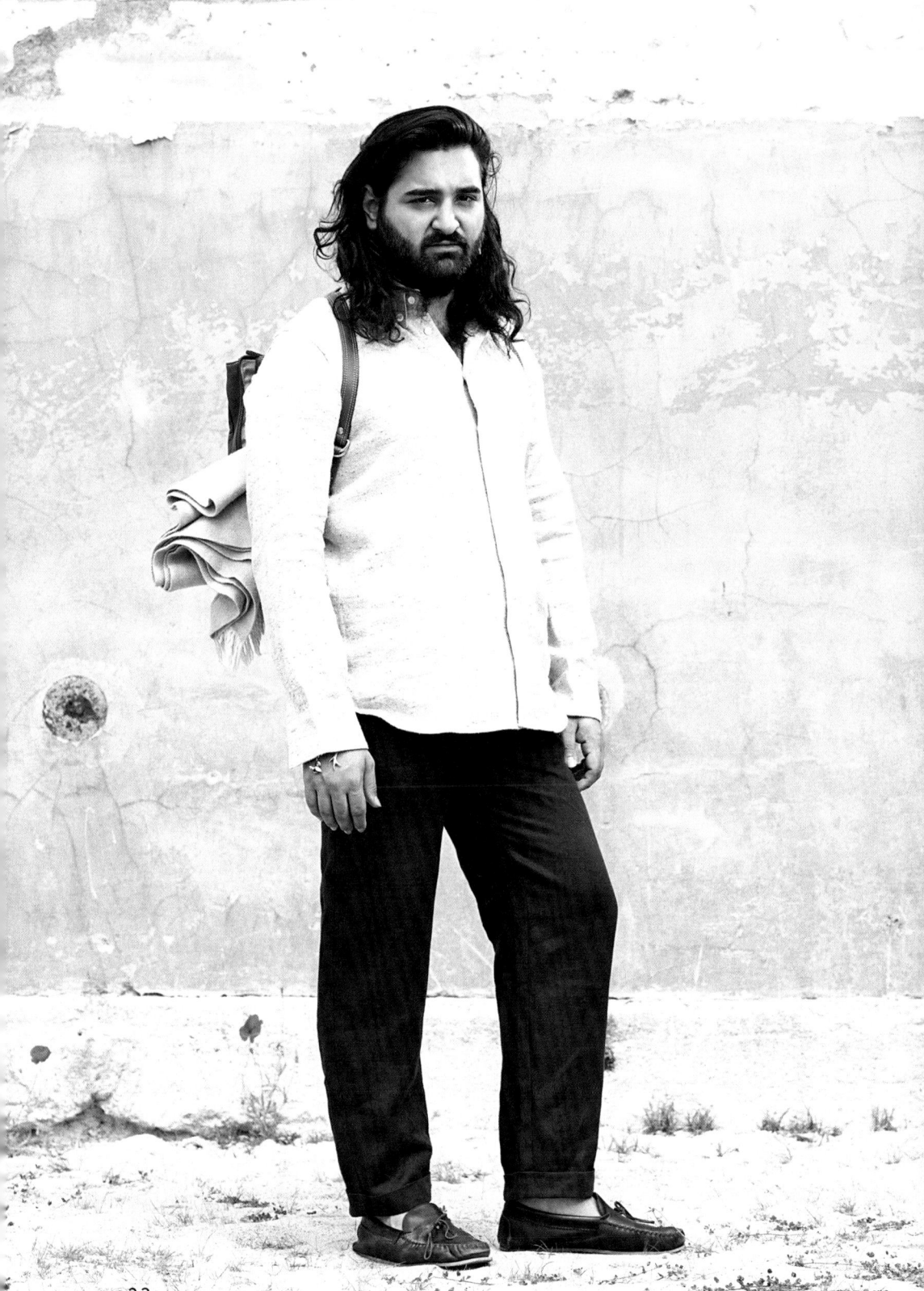

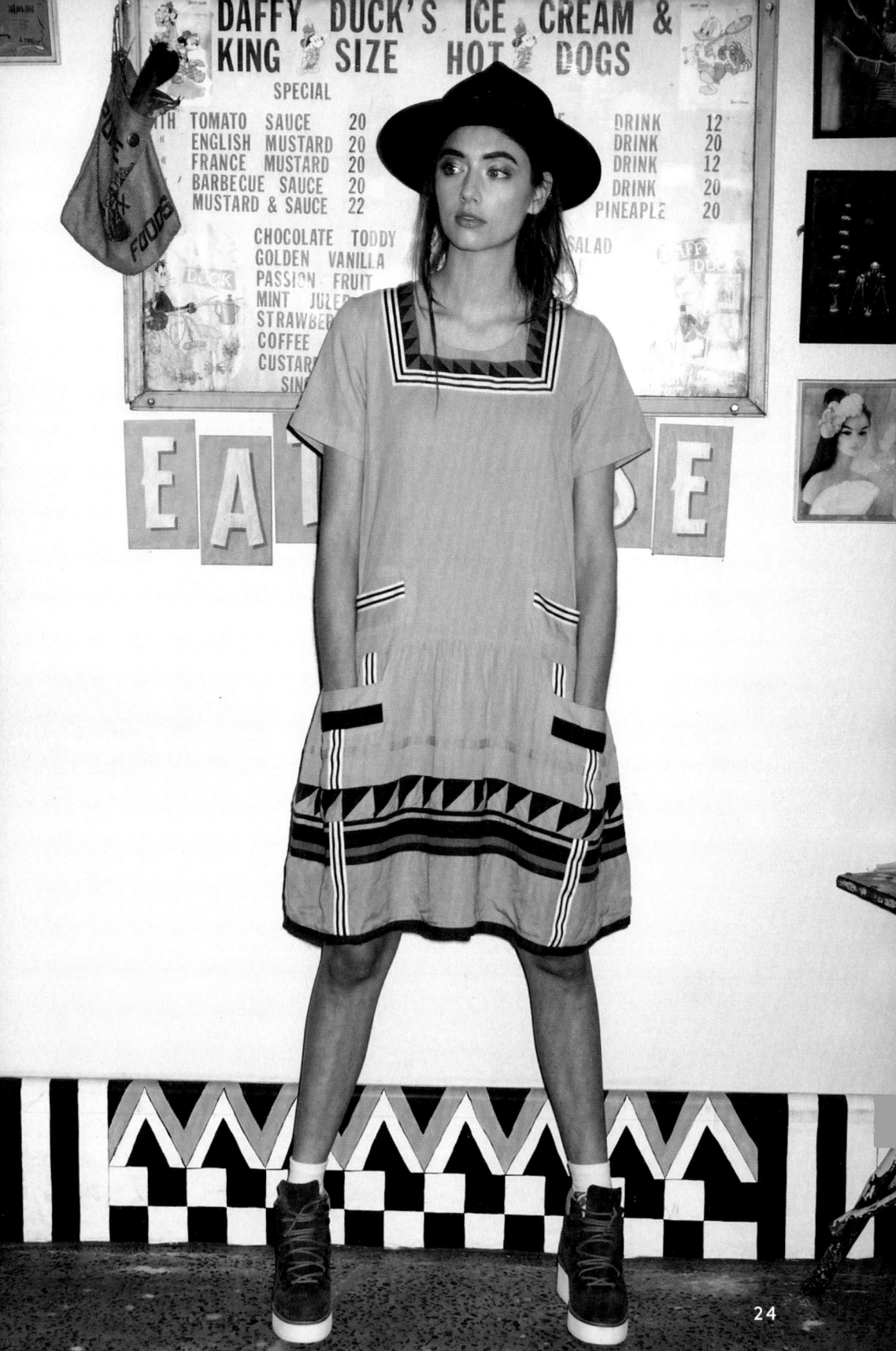

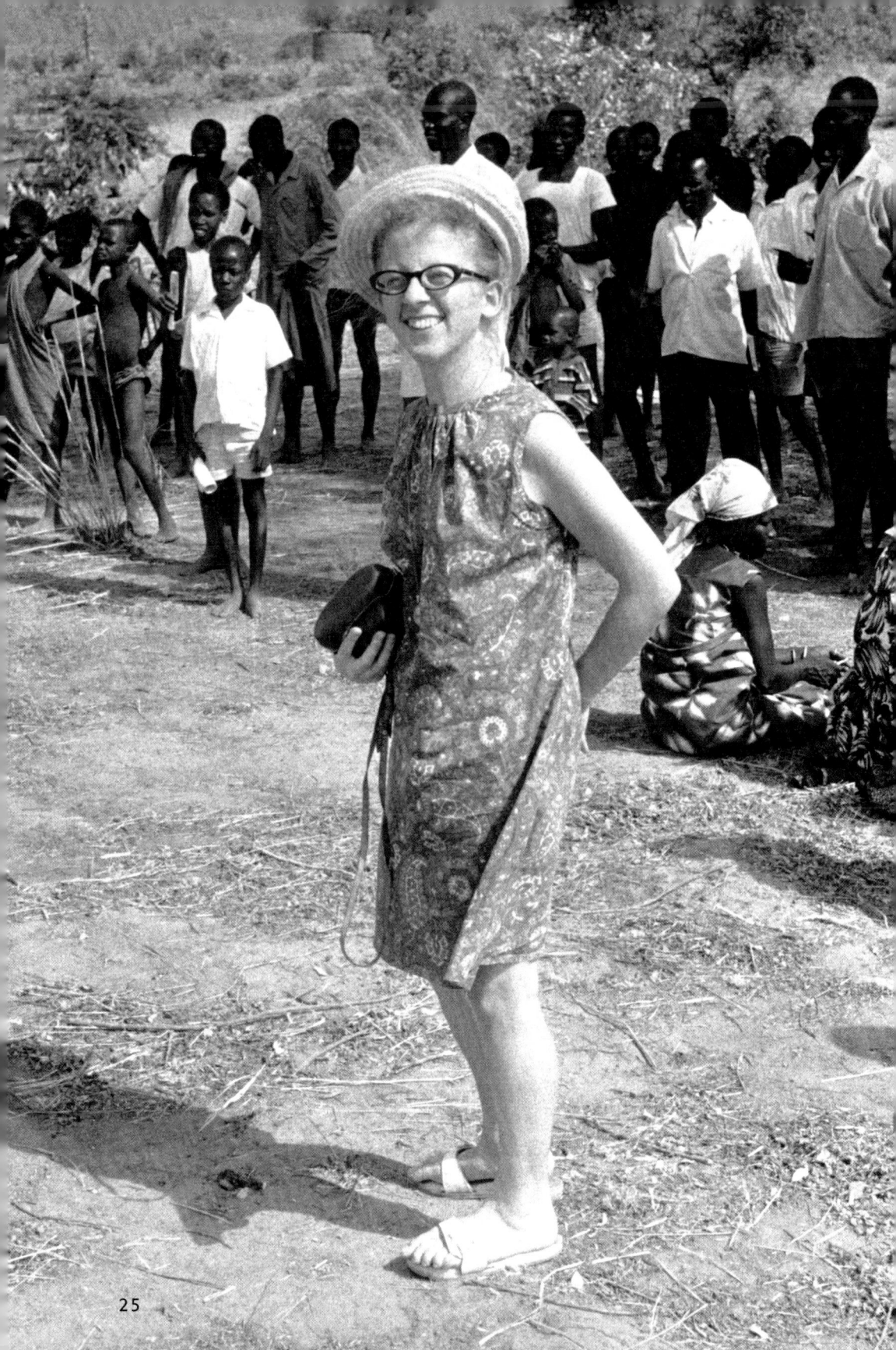

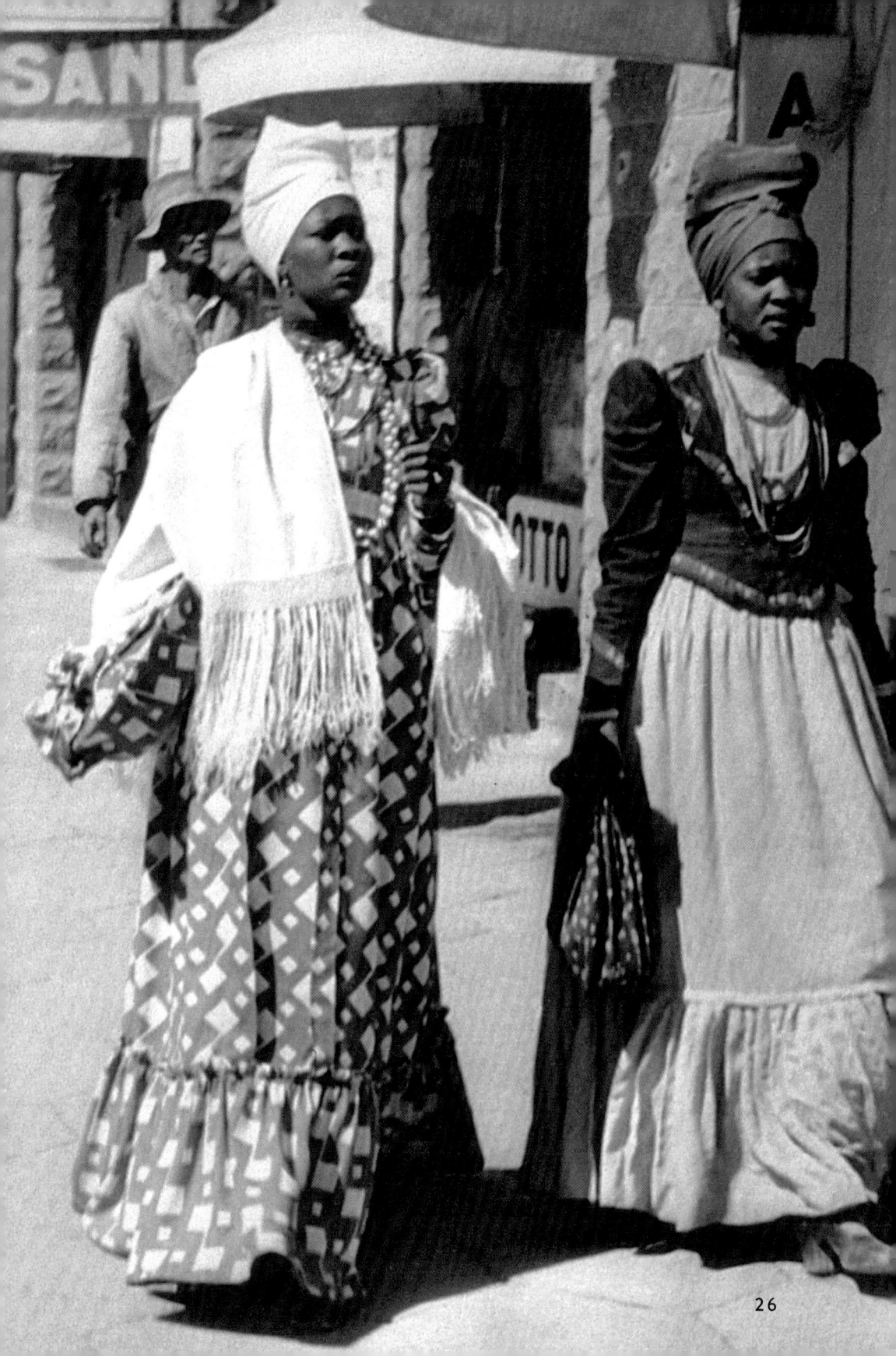

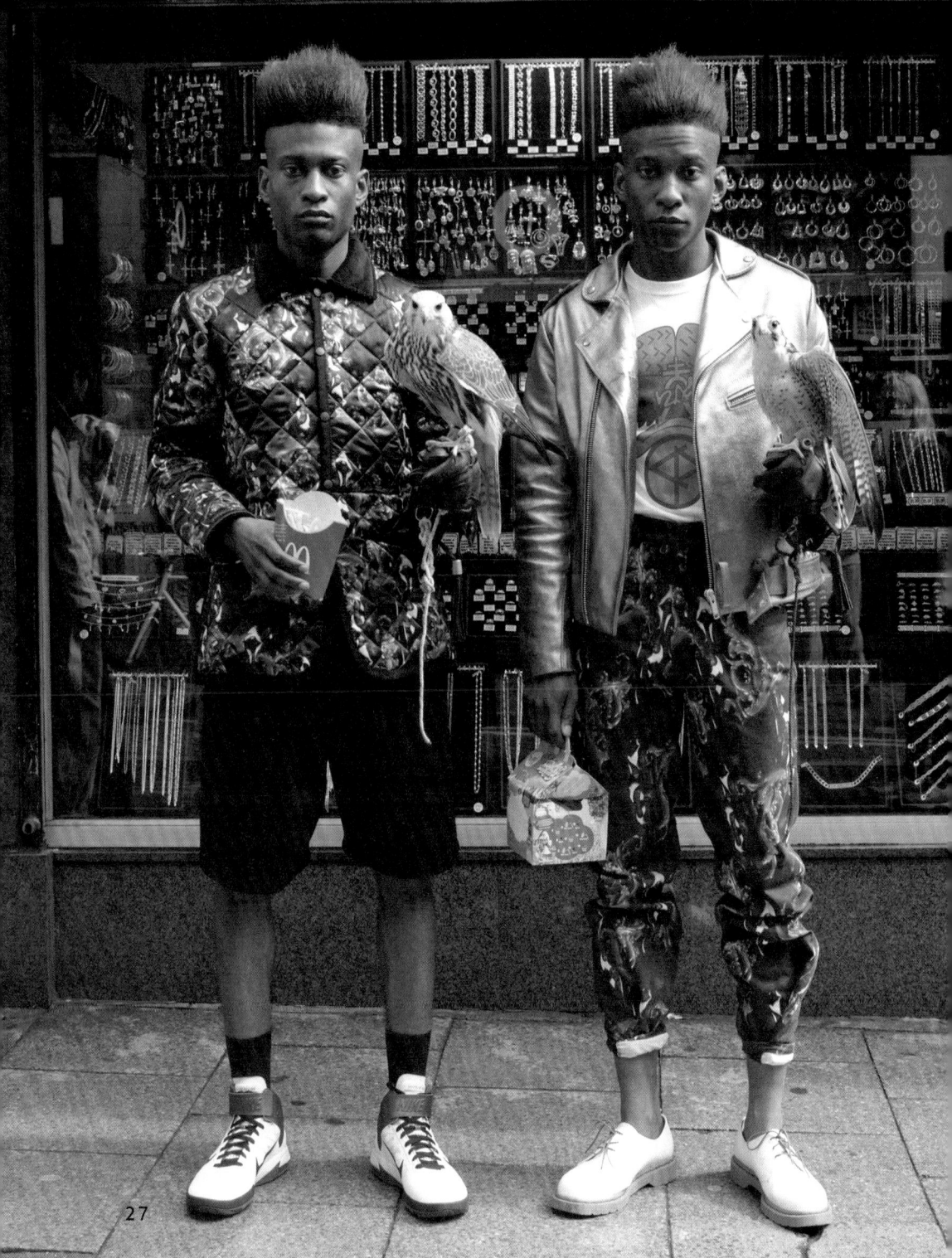

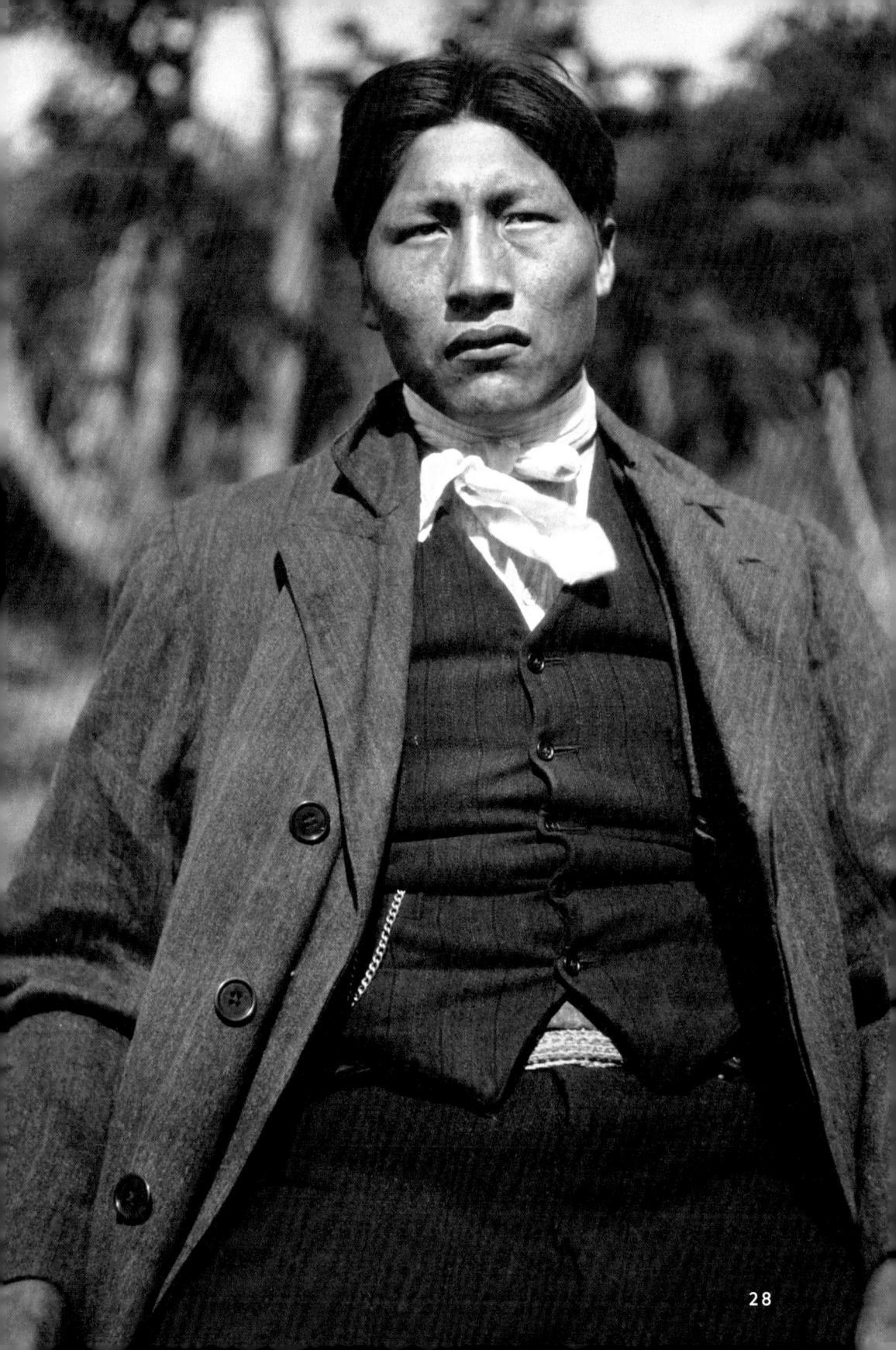

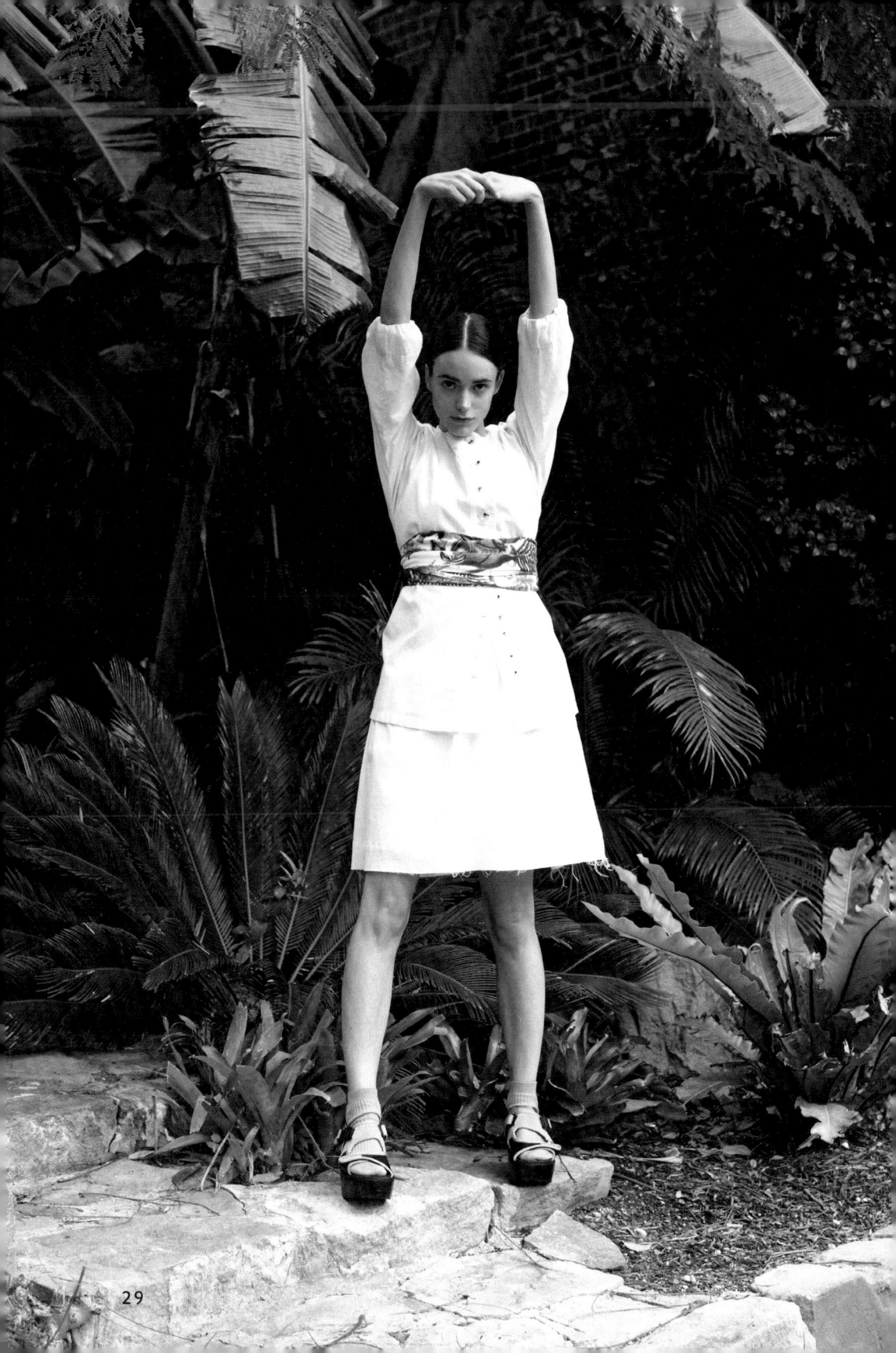

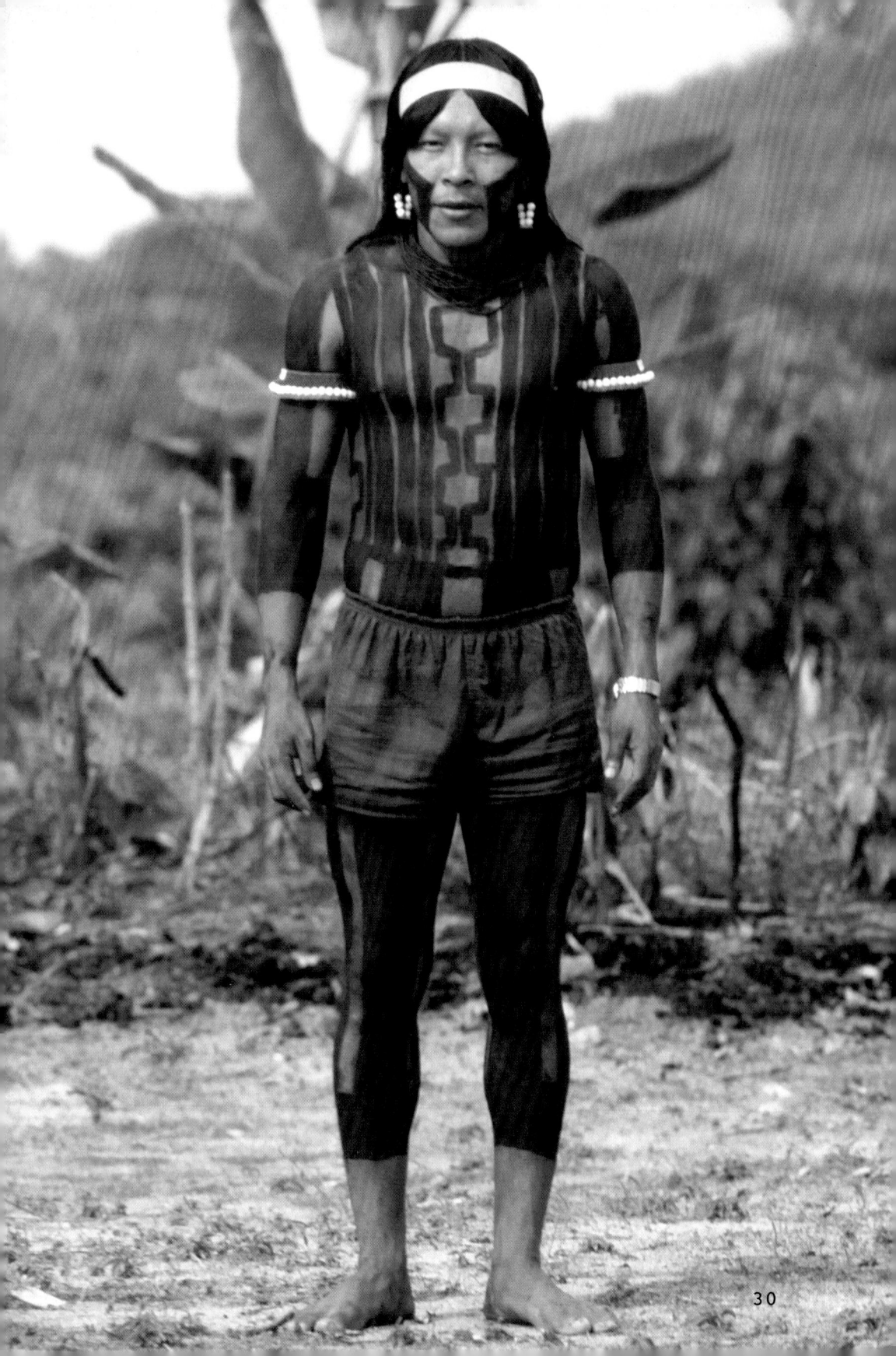

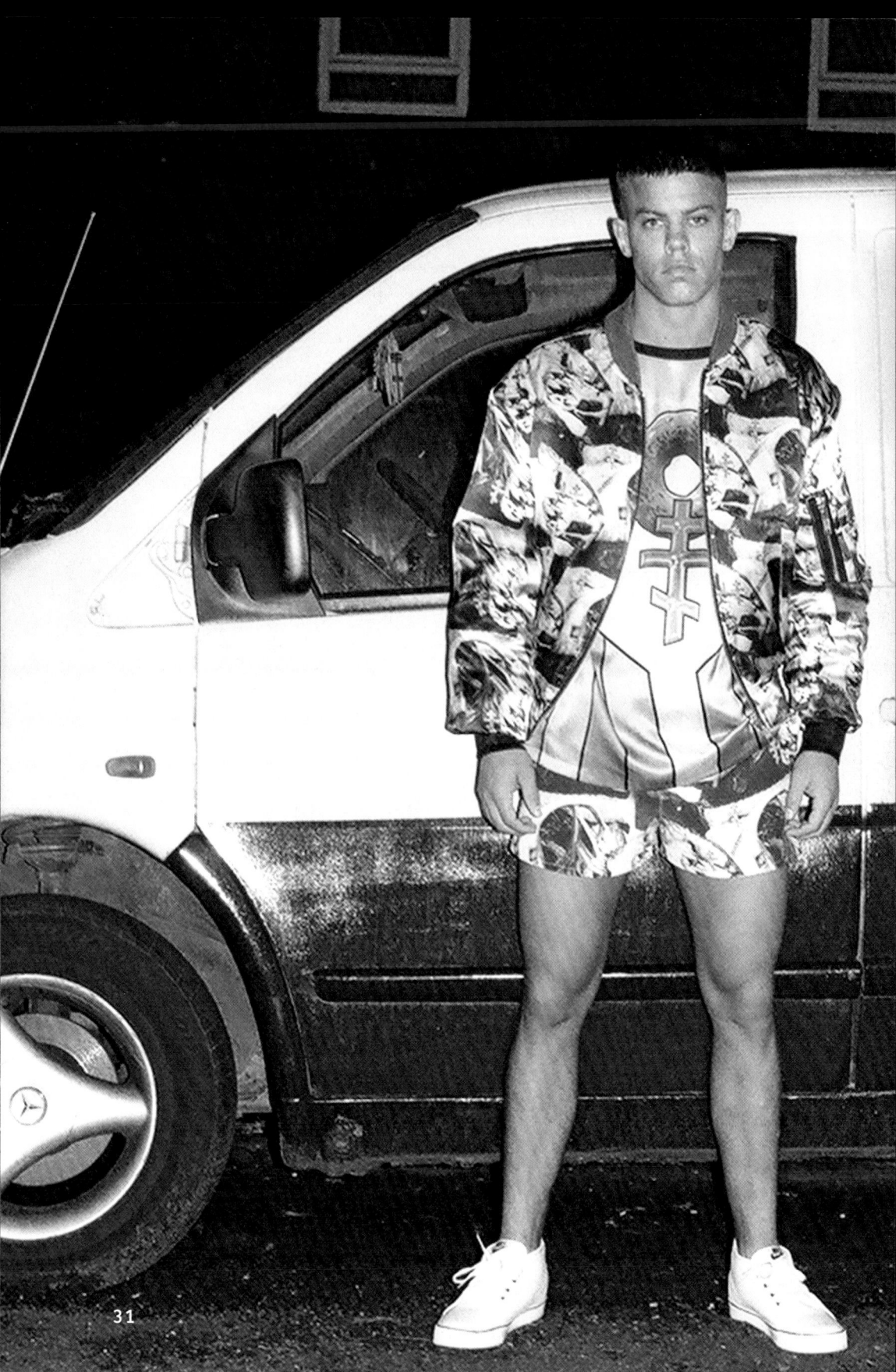

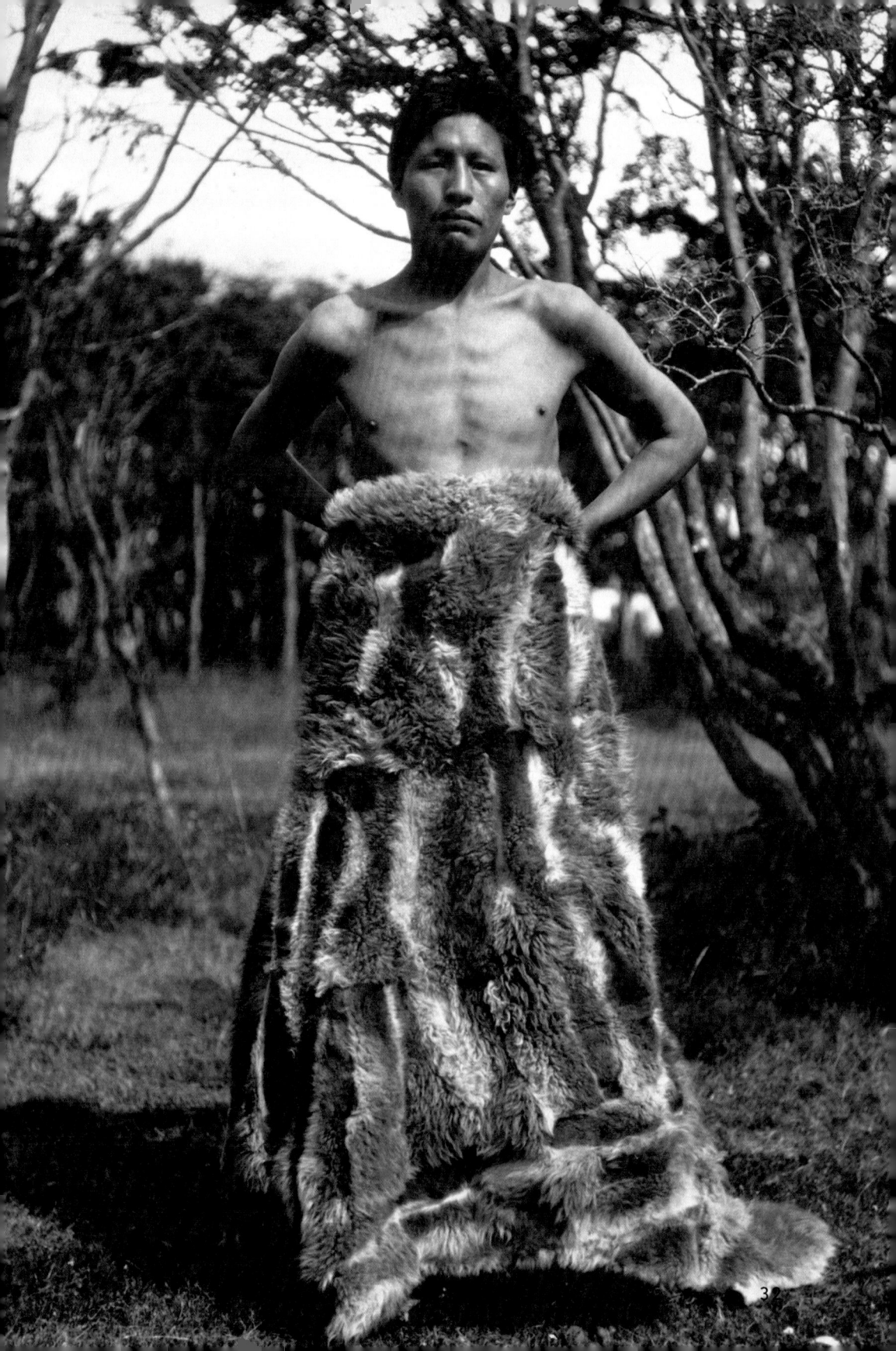

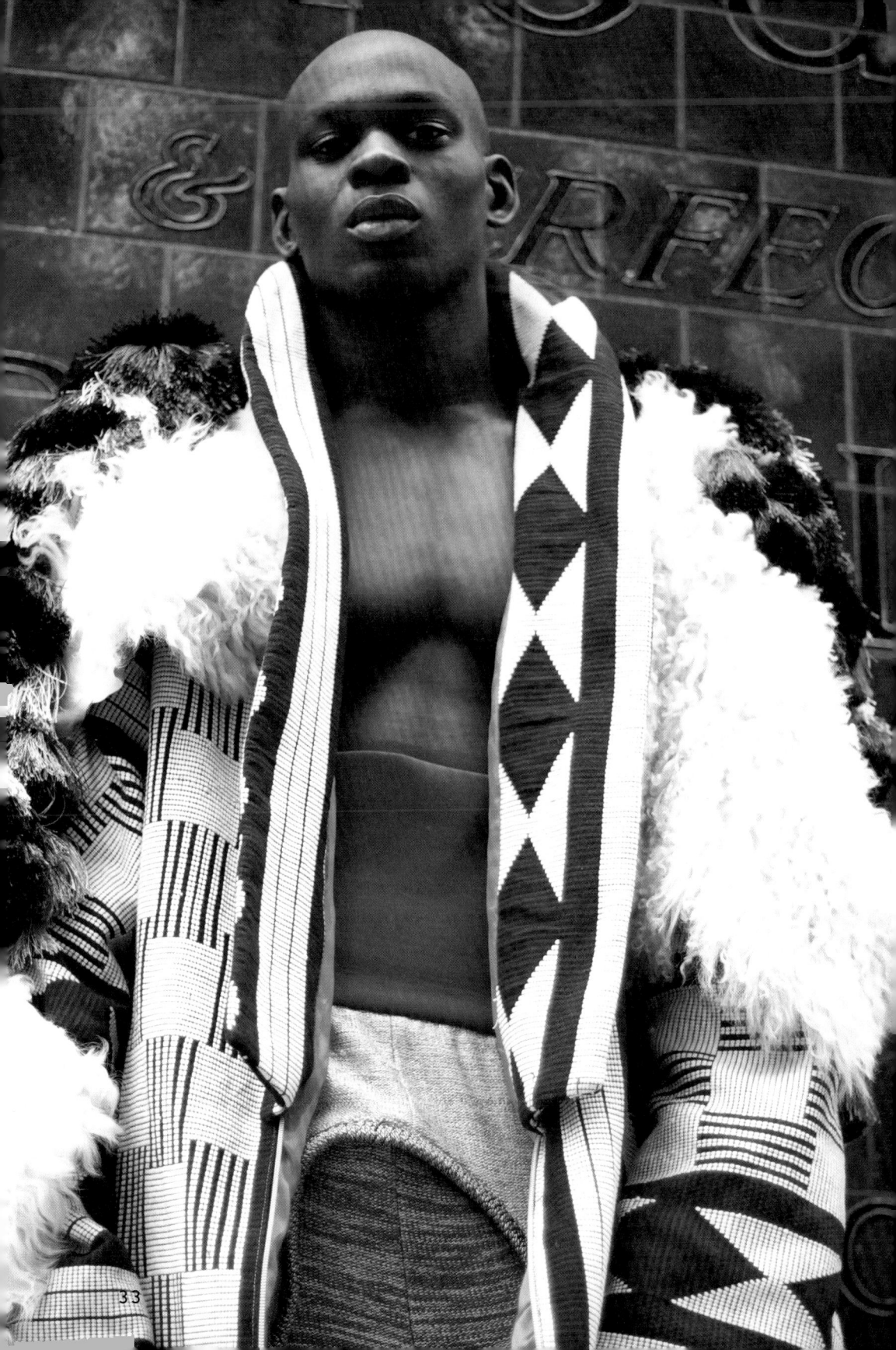

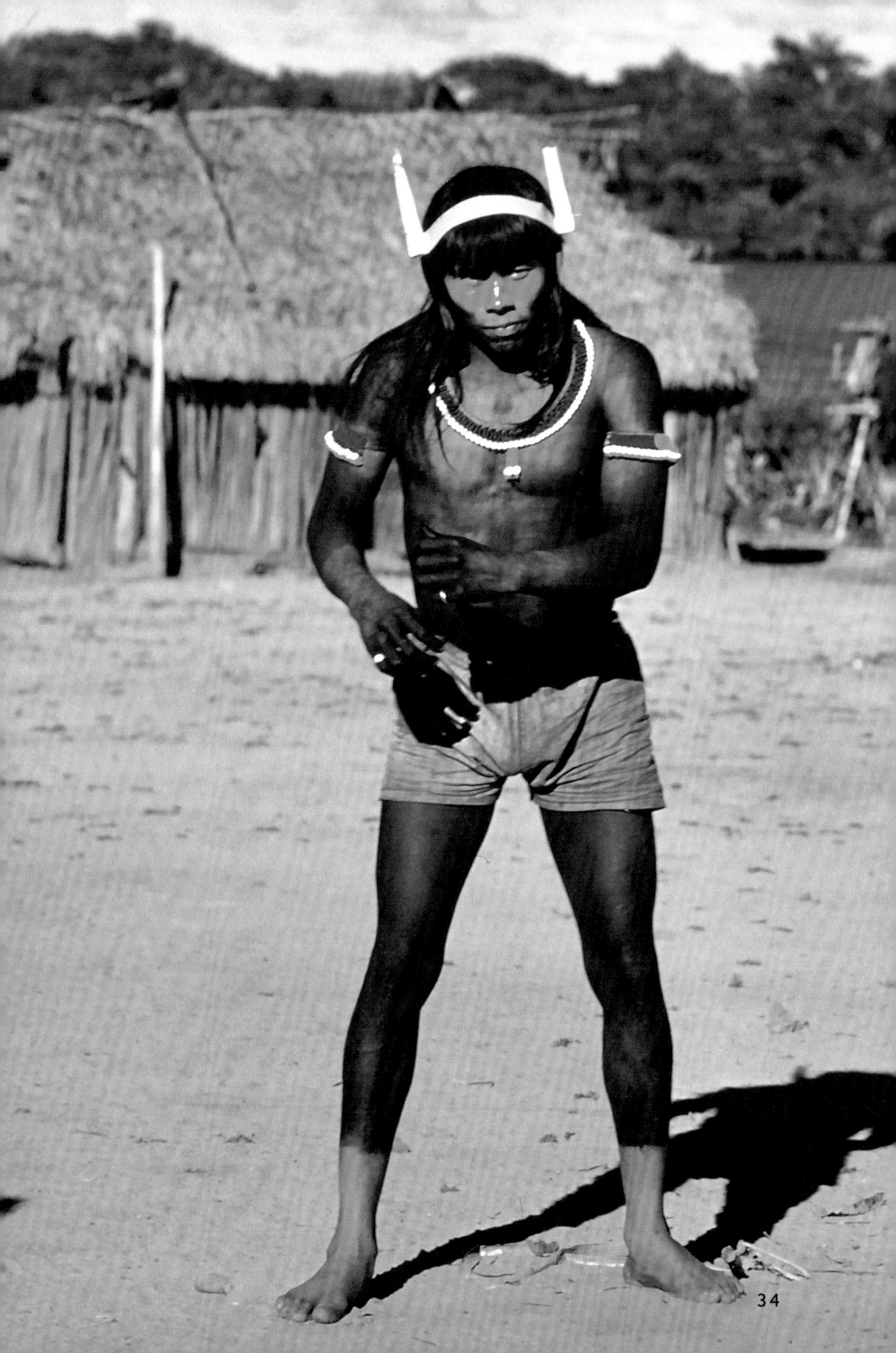

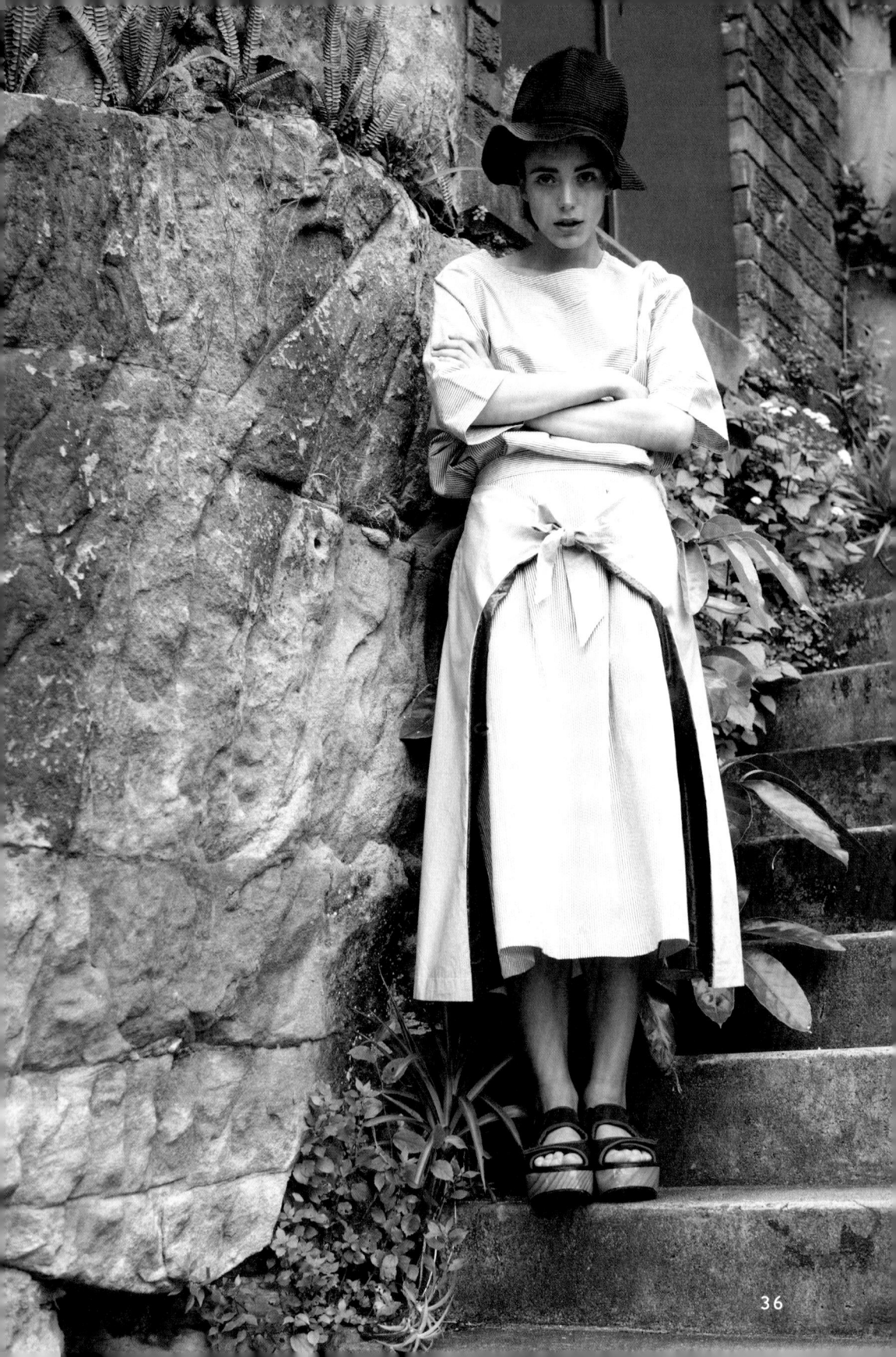

37

42

43

44

48

49

50

54

55

58

59

62

63

64

70

71

73

74

80

81

83

88

89

90

91

92

93

94

COLLECTION

100

101

102

106

107

115

116

119

120

122

123

130

137

139

141

142

144

145

147

148

149

150

151

154

155

157

160

161

162

163

164

165

166

168

169

170

174

175

178

180

COLLECTION OF THE COLLECTION

Love attraction

Define an atmosphere

Fill it with individuality

Sense the environment

Fashion is a fast-paced business

Have an adventure in the present

Don't wait for the right moment

An intuitive, high-speed reaction is necessary

Everything and everyone can influence fashion

Be naturally self-aware

Style is organic

Bodies in transition

Make things

Have no control

If air could talk

The principle of flavour

Take today's taste one step further

Be inspired by your ancestors' calls

Give a contemporary response

Unlock the stored code of the past for the next generation

Fashion craves new blood

Exchange, trade, express different influences

Represent consciousness, culture, information

Performative tribes

Hand-made

Don't touch without gloves

Learn from textiles

Plastic blue dress-code

Inexplicable objects

Bark-cloth, weaving, rain

Pottery

Connect to the countryside

Love inspiration

We are consumers

Trade identities

Eating, art, fashion, that's where mankind began

What did prehistoric man do first: build a house or a community?

Create a space, open a lab

Everything you do has a consequence

We never worry about others copying this or that design

because we've already moved on

Research follows research

Prototypes

Modern ethnographic

Exchanging exotica

Emporia

Ships

Future primitive

Graphic warrior technologies

Psychedelic, digital, global street-wear

Patterns, rituals, body modifications

Re-contextualise your ancestors' style

Gleaming patterns of sound

Stored knowledge

Some things are good as they are

You don't have to change anything

DIY

No business plan

Made in Germany

World-wide tribe

Quintessentially Nigerian

Nation or world show?

Recover the capacity of the street

Move below the radar

Make presence

Swagger

Accelerated fashion

Trading style

WELTKULTUREN MUSEUM RESIDENCY, JUNE 2012

BUKI AKIB

194

KNIT PIPING

LEATHER BINDING

LEATHER PLEATS

WELTKULTUREN MUSEUM RESIDENCY, APRIL 2012

A KIND OF GUISE

206

208

209

210

212

215

216

WELTKULTUREN MUSEUM RESIDENCY, MAY/AUGUST 2012

Established 1983

Best Value for Diamonds, Gold and

CASSETTE PLAYA

222

223

224

225

228

229

230

231

WELTKULTUREN MUSEUM RESIDENCY, JULY 2012

P.A.M.

234

236

237

238

239

242

244

SOSA

KAMAYURA PRINT

T-SHIRT DRESSES (PAM TO SUPPLY BLANKS)

FABRIC - TBC (COTTON SHIRTING TWILL)

246

GRIMACE PRINT

SCARFS

247

248

TBC

249

BUKI AKIB

The Nigerian designer Buki Agbakiaka studied Fashion Design with a special focus on knitwear at Central Saint Martins College of Art and Design in London from 2006 to 2010. Buki Akib's designs are distinctive for their deep, strong colours, colliding patterns and textures – sometimes three-dimensional – which generate an energetic vitality in a fashion range that is unique, daring and extravagant. The title of her most recent collection of menswear is "Homecoming – A journey into an idealised future", which refers to the young man of Lagos coming home to reclaim the city and his identity. "FELA", Buki Akib's first and critically acclaimed menswear collection is influenced by the pulsating rhythms of Afrobeat, and inspired by the groundbreaking musician Fela Kuti, whose legendary, unmistakable style marked the beginning of a new extroversion in the West and Pan-African music scenes. Akib takes a moment in her country's past and transposes it into fashion's future, playing creatively with her own Nigerian heritage. All the pieces in her collections are produced in both Lagos and London.

Die nigerianische Designerin Buki Agbakiaka studierte von 2006 bis 2010 Modedesign mit Schwerpunkt auf Strickware am Central Saint Martins College of Art and Design in London. Ihre Designs zeichnen sich durch tiefe, kräftige Farben, kollidierende, teilweise dreidimensionale Muster und Texturen aus, die eine energetische Lebendigkeit erzeugen und ihre Mode zu gewagten, einzigartigen und extravaganten Stücken machen. Ihre jüngste Männerkollektion „Homecoming – A journey into an idealised future" ist inspiriert vom Bild eines jungen Heimkehrers nach Lagos, der seine Stadt und seine Identität zurückerobert. „FELA", ihre erste Männerkollektion, ist beeinflusst von den pulsierenden Rhythmen der Afro-Beat-Bewegung der 70er Jahre und inspiriert von dem bahnbrechenden Musiker Fela Kuti, der mit seinem legendären und unverwechselbaren Stil eine neue Ära der Selbstdarstellung in den west- und panafrikanischen Musik-Szenen einläutete. Akib greift vergangene Momente auf und transferiert sie in die Zukunft der Mode. Gleichzeitig spielt sie in einem kreativen Prozess mit ihrem eigenen nigerianischen Erbe. Alle Kleidungsstücke von Buki Akib werden sowohl in Lagos als auch in London produziert.

A KIND OF GUISE

The fashion label A Kind of Guise was founded in Munich in 2009. The team behind the brand name consists of Yasar Ceviker and Susi Streich, the two founders of the label, plus four young designers with diverse backgrounds and experience in music, art and design. All of them share a similar urge to express themselves and all cite tradition, function and detail as the base of their creations. They seek to incorporate everyday influences into their products and in so doing to develop new perspectives and express their approach to life. Fashions from A Kind of Guise are unpretentious, useful and practical, with an emphasis on beauty and simplicity. They are known for their clear hues and contemporary, casual cuts. All the items in their collection are made exclusively in Germany.

Das Mode-Label A Kind of Guise wurde im Sommer 2009 in München gegründet. Das Team hinter dem Markennamen setzt sich zusammen aus Yasar Ceviker und Susi Streich, den beiden Gründern des Labels, und vier weiteren jungen Designern mit unterschiedlichem Hintergrund und Prägung in den Bereichen Musik, Kunst und Design. Sie verbindet das Bedürfnis, sich selbst auszudrücken, und sie alle beschreiben die Tradition, die Funktion und das Detail als Grundlage ihrer Kreationen. Sie versuchen die alltäglichen Einflüsse in ihre Produkte zu übersetzen und damit wiederum neue Perspektiven zu entwickeln und ihre Lebenseinstellung offen zu zeigen. Die Mode von A Kind of Guise ist unprätentiös, zweckmäßig und praktisch, die Schönheit und Schlichtheit steht im Vordergrund. Die Designer sind bekannt für klare Töne und zeitgemäße, legere Schnitte. Alle Teile ihrer Kollektion werden ausschließlich in Deutschland hergestellt.

CASSETTEPLAYA

CassettePlaya is the fashion label of the London-based designer Carri Munden – an international luxury women's and menswear brand with a reputation for cult graphics and digital prints. Munden studied Fashion Design at the University of Westminster and presented her first CassettePlaya collection as part of Fashion East MAN in 2006. For the last eight out of twelve seasons, CassettePlaya has chosen digital forms of display using film, animation, sound, augmented reality and interactive digital installations to push the boundaries of fashion presentation. In 2007 Carri was nominated for "Best Menswear Designer" at the British Fashion Awards alongside Christopher Bailey and Alexander McQueen. In 2008 CassettePlaya was awarded "Best Fashion Designer" in Rolling Stone's "Best of Rock" issue. Designer Carri Munden has worked with artists such as M.I.A., Nicki Minaj, Jessie J, 2NE1, Lil Wayne and Riff Raff. CassettePlaya has collaborated and worked with brands including Nike, Sega, Jim Henson, Nintendo, Stussy, Swatch, Phenomenon JP, Rockers NYC, Medicom and Mattel.

CassettePlaya ist das Mode-Label der Londoner Designerin Carri Munden – ein internationales Luxuslabel für Frauen- und Männermode mit einer Reputation für Kultgrafik und Digitaldruck. Munden studierte an der University of Westminster Modedesign und präsentierte 2006 im Rahmen von Fashion East MAN ihre erste CassettePlaya-Kollektion. In den letzten acht von zwölf Kollektionen hat sich CassettePlaya bewusst für eine digitale Präsentation entschieden, die mit Film, Animation, Ton, Augmented Reality und interaktiven digitalen Installationen die Grenzen der Modepräsentation überschreitet. 2007 war Carri Munden neben Christopher Bailey und Alexander McQueen für die Auszeichnung des „Best Menswear Designer" bei den British Fashion Awards nominiert. 2008 wurde sie vom Rolling Stones Magazine zum „Best Fashion Designer" in der Kategorie „Best of Rock" ernannt. Carri Munden arbeitete für Künstler wie M.I.A., Nicki Minaj, Jessie J, 2NE1, Lil Wayne und Riff Raff. CassettePlaya kooperierte u.a. mit Nike, Sega, Jim Henson, Nintendo, Stussy, Swatch, Phenomenon JP, Rockers NYC, Medicom und Mattel.

P.A.M.

P.A.M./Perks and Mini is an Australian lifestyle brand that was founded in Melbourne in 2000. The brains behind the label are Misha "Perks" Hollenbach and Shauna "Mini" Toohey. They both studied at the Royal Melbourne Institute of Technology, where Hollenbach graduated in fine art and painting and Toohey in fashion design. This designer duo finds their inspiration in music, art and fashion and practically everything in their surroundings affecting their lives – including food. P.A.M. is distinguished by its unmistakable graphic style and the supreme attention paid to detail in all its products. The label is known for bright colours and bold, original graphic designs. With its mixture of street culture and high fashion, P.A.M. has rapidly attained cult status in the international market for men's and women's fashions. With its innovative, forward thinking products P.A.M. breaks through the barriers of classic fashion. P.A.M. refuses to be deflected by economic success or business goals, for their interest is in personal development through constant learning and exploration. P.A.M. has its own stores in Melbourne and Sydney.

P.A.M./Perks and Mini ist eine australische Lifestyle-Marke, die im Jahr 2000 in Melbourne gegründet wurde. Hinter dem Label verbergen sich Misha „Perks" Hollenbach and Shauna „Mini" Toohey. Beide besuchten das Royal Melbourne Institute of Technology, wo Hollenbach Bildende Kunst und Malerei und Toohey Modedesign studierte. Ihre Inspiration bezieht das Designerpaar aus der Musik, der Kunst und der Mode und praktisch aus allem, was sie umgibt und beeinflusst, wie beispielsweise Essen. P.A.M. zeichnet sich durch eine unverwechselbare Grafik-Sprache und eine ausgeprägte Aufmerksamkeit für Details aus. Das Label ist bekannt für die Verwendung von hellen Farben und kühnen, originellen Grafiken. Durch die Vermischung von Straßenkultur mit High Fashion erlangte die Marke in kurzer Zeit einen internationalen Kultstatus im Bereich der Herren- und Damenmode. Mit innovativen und zukunftsorientierten Produkten durchbricht P.A.M. die Grenzen der klassischen Mode. P.A.M. lässt sich nicht durch wirtschaftliche Erfolge oder Geschäftsziele lenken. Die Designer sind vielmehr an der persönlichen Weiterentwicklung durch ständiges Lernen und Erforschen interessiert. P.A.M. hat eigene Geschäfte in Melbourne und Sydney.

GLOBAL STYLES
18 - 94

22
PORTRAIT OF A MAN IN LONG-SLEEVED SHIRT AND PANTS
Matakam, Cameroon,
West Africa.
Photo: Johannes Lukas, 1952.
Weltkulturen Museum.

23
A KIND OF GUISE
Painter Shirt, Wide Summer Pants, Backpack Bag.
A few days in Beirut S/S 2012.
Photo: Julian Henzler.

24
P.A.M.
Ndebele Dress, Langosta Socks, Roccia Lifted Boots (PAM x Diemme), Paris Mexico Hat.
Paris Mexico A/W 2012.
Photo: Max Doyle.

25
WOMAN IN SUMMER DRESS AND STRAW HAT
Cameroon, West Africa.
Photo: Johannes Lukas, 1960.
Weltkulturen Museum.

26
WOMEN ON A SHOPPING TRIP
South Africa.
Photographer unknown, 1930.
Archive of the Jesuits.
Weltkulturen Museum.

27
CASSETTEPLAYA
Kadeem + Kyrone Oak,
E5 London 2012.
Quilted Digital Print Jacket, Shorts, Digital Print Trousers, Screen Printed Tee Shirt.
Carni Cannibal Palace A/W 2012/13.
Photo: Alis Pelleschi.

28
PORTRAIT OF A MAN IN A SUIT
Tierra del Fuego, South America.
Photo: Martin Gusinde, 1918–1924.
Anthropos Institute, St. Augustin.
Weltkulturen Museum.

29
P.A.M.
Healing Blouse, Tropic of Leggings (worn as belt), Newcomer Dress.
Deep Forest Remix S/S 2012.
Photo: Max Doyle.

30
BONTI-RE WITH FRESHLY APPLIED BODY PAINT
Kayapó-Mekragnoti, Pará, Brazil.
Photo: Gustaaf Verswijver, 1980.
Weltkulturen Museum.

31
CASSETTEPLAYA
Ryan Pickard 2011.
Digital Print Jacket, Tee Shirt and Shorts.
Human Katamari S/S 2012.
Photo: Michael Mayren.

32
EDUARDO WATENI, 25 YEARS OLD
Selk'nam, Tierra del Fuego, South America.
Photo: Martin Gusinde, 1918–1924.
Anthropos Institute, St. Augustin.
Weltkulturen Museum.

33
BUKI AKIB
Fela Jacket.
FELA A/W 2011.
Photo: Milly Kellner.

34
YOUNG MAN TAKING PART IN TÀKÀK DANCE
Kayapó-Kretire, Pará, Brazil.
Photo: Gustaaf Verswijver, 1974.
Weltkulturen Museum.

35
CASSETTEPLAYA
Osaka Street Style 2010.
Digital Print Tee Shirt and Shorts, Jeremy Scott Bag.
Power Drift Nation S/S 2010.
Photo: Carri Munden.

36
P.A.M.
Maze Woven Tee, Tarp Striped Skirt, Warped Record Hat, Rousseau Sandals.
Deep Forest Remix S/S 2012.
Photo: Max Doyle.

37
NELLIE'S DAUGHTER IN WHITE EMBROIDERED DRESS
Selk'nam, Tierra del Fuego, South America.
Photo: Martin Gusinde, 1918–1924.
Anthropos Institute, St. Augustin.
Weltkulturen Museum.

38 - 39
A KIND OF GUISE
Hidalgo Shirt, Colima Sweater, Reversible Jacket No3, Nevada Shirt.
Viva la Mexico S/S 2013.
Photo: A Kind of Guise.

40 - 41
FATHER LAMBERT, THEISSEN, MOBEIR AND MR. KARL SIT OVER COFFEE
Togo, West Africa.
Photo: Heinrich Basten, 1911.
Archive of the Societas Verbi Divini, Steyl.
Weltkulturen Museum.

42
THE GATE OF ALL NATIONS
Persepolis, Iran.
Photo: Milli Bau, 1971.
Weltkulturen Museum.

43
UNKNOWN COUPLE, SAFARI LODGE
Uganda, East Africa.
Photo: Gert Chesi, 1967.
Weltkulturen Museum.

44
P.A.M.
Ido Jersey Tee, Haabo Cardigan, Okuba Trousers, Leather Belt.
POP! Eyes Collection I A/W 2009.
Photo: Max Doyle.

45
YOUNG WOMAN POSING IN A BAMBOO GROVE
Lesser Sunda Islands, Indonesia.
Photographer unknown, 1930.
Archive of the Societas Verbi Divini, Steyl.
Weltkulturen Museum.

46
WIFE OF TERRITORIAL SERGEANT OF BAGATA
Banza-Lute, Democratic Republic of Congo,
Central Africa.
Photo: Josef Franz Thiel, 1963.
Weltkulturen Museum.

47
JEROME, COOK, WEARING GLASSES LENT BY PHOTOGRAPHER
Banza-Lute, Democratic Republic of Congo,
Central Africa.
Photo: Josef Franz Thiel, 1961.
Weltkulturen Museum.

48
COUPLE
Former Cape Province, South Africa.
Photographer unknown, 1930.
Central Province Archive of the Pallottines, Limburg.
Weltkulturen Museum.

49
P.A.M.
Thumbs Marbel Pants, V Military Overshirt, Mellow Puffa Jacket, Drum Tube Scarf, Moana Rox Tee, Verse Cardigan, Ms Duplo Pants, Alpine-Apple Scarf.
Good/Bad A/W 2010.
Photo: Shauna Toohey.

50
WOMAN IN MORTUARY DRESS
Miao, Tak Province, Thailand, South East Asia.
Photo: Hermann Schlenker, 1964/65.
Weltkulturen Museum.

51
P.A.M.
Tempo Top, Goude Trouser,
Deep Echo Long Sleeve Top,
Vibrations Leggings, Rousseau
Sandals.
Deep Forest Remix A/W 2012.
Photo: Max Doyle.

52
WATERFALL AT
MISSAHOE
Missahoe, Togo, West Africa.
Photographer unknown, 1907.
Archive of the Societas Verbi
Divini, Steyl.
Weltkulturen Museum.

53
P.A.M.
Thou Wilt Sweater Dress,
Knitted Radar Style Hat.
Around & Around A/W 2008.
Photo: Peter Sutherland.

54
A KIND OF GUISE
Reversible Jacket No3,
Bernal Tie.
Viva la Mexico S/S 2013.
Photo: A Kind of Guise.

55
MAN IN TRADITIONAL
DRESS
Cameroon, West Africa.
Photo: Johannes Lukas, 1952.
Weltkulturen Museum.

56
P.A.M.
Laura Heavy Jumpsuit.
Wild Wild Life A/W 2011.
Photo: Rene Vaile.

57
DAUGHTER OF
JOHANNES LUKAS IN
SHORT SUMMER DRESS
Cameroon, West Africa.
Photo: Johannes Lukas, 1952.
Weltkulturen Museum.

58
"BIG MAN"
Simbu Province, Papua
New Guinea.
Photo: Petrus Beltjens,
1950–1955.
Archive of the Societas Verbi
Divini, Rome.
Weltkulturen Museum.

59
P.A.M.
Jackhard Long Sleeve Top,
Heavy Groove Marbel Pants.
Club PAM S/S 2012.
Photo: Rene Vaile.

60
PORTRAIT OF PÁNH'O
WITH FACE PAINTING
Kayapó-Mekragnoti,
Pará, Brazil.
Photo: Gustaaf Verswijver, 1977.
Weltkulturen Museum.

61
CASSETTEPLAYA
Toby Leonard.
Film still from "Blood Rites"
2012.
Director: Santiago Arbelaez.
Art Director: Carri Munden.
Body Art: Bea Sweet.

62
GIRL'S HAIRSTYLE
Buli, Cameroon, West Africa.
Photographer unknown,
1901–1916.
Central Province Archive of the
Pallottines, Limburg.
Weltkulturen Museum.

63
PORTRAIT OF A MAN
WITH FEATHERS
KwaZulu-Natal, Republic
of South Africa.
Photo: Artco, 1930.
Central Province Archive of the
Pallottines, Limburg.
Weltkulturen Museum.

64
MAN WITH PIPE, NECK
JEWELLERY AND BEADED
EMBROIDERED HAT
Former Cape Province,
South Africa.
Photographer unknown, 1930.
Central Province Archive of the
Pallottines, Limburg.
Weltkulturen Museum.

65
YOUNG WOMAN WITH
FACE PAINT
Former Cape Province,
South Africa.
Photographer unknown, 1930.
Central Province Archive of the
Pallottines, Limburg.
Weltkulturen Museum.

66
P.A.M.
Higherarchy Flannel Sweater,
Tranced Lucent Plastic Tee,
Marbel Pant, Woodlands Scarf,
High Dye Sports Socks.
The High Life A/W 2012.
Photo: Peter Sutherland.

67
COSTUME OF THE
YINCIHAUA SPIRIT
Halakwulup, Tierra del Fuego,
South America.
Photo: Martin Gusinde,
1918–1924.
Anthropos Institute, St. Augustin.
Weltkulturen Museum.

68
NEW YEAR'S DANCER
Teheran, Iran.
Photo: Milli Bau, 1966.
Weltkulturen Museum.

69
BUKI AKIB
White Broderie Anglaise
Lace with Knitted Piping.
HOMECOMING 2012.
Photo: Lakin Ogunbanwo.

70
MEN WITH THREE-
CORNERED HATS,
BALLOON SLEEVES AND
SUSPENDER BELTS
Location unknown.
Photographer unknown,
end of 19th century.
Archive of the Jesuits.
Weltkulturen Museum.

71
CASSETTEPLAYA
Home Slice Shoot for Clash
Magazine 2011. Jacket with
Hand Painted Graphics, Shorts,
Bomber Jacket, Track Suit
Bottoms, Shirt with Hand
Painted Graphics, Denim Two-
Tone Jeans.
Carni Cannibal Palace A/W
2011/12.
Styling: Matthew Josephs.
Photo: Mark Kean.

72
WOMEN WITH BEADED
AND EMBROIDERED
DRESSES
Former Cape Province,
South Africa.
Photographer unknown, 1930.
Central Province Archive of the
Pallottines, Limburg.
Weltkulturen Museum.

73
TRUCK DRIVERS
Bayansi, Banza-Lute,
Democratic Republic of Congo,
Central Africa.
Photo: Josef Franz Thiel, 1962.
Weltkulturen Museum.

74
MAN AND WOMAN WITH
FACE PAINTING,
POSSIBLY WITCHDOCTORS
Former Cape Province,
South Africa.
Photographer unknown, 1930.
Central Province Archive of the
Pallottines, Limburg.
Weltkulturen Museum.

75
CASSETTEPLAYA
Kadeem + Kyrone Oak,
E5 London 2012.
Quilted Digital Print Jacket,
Shorts, Digital Print Trousers,
Screen Printed Tee Shirt.
Carni Cannibal Palace A/W
2012/13.
Photo: Alis Pelleschi.

76
YOUNG MAN WITH
DANCE JEWELLERY
Former Cape Province,
South Africa.
Photographer unknown, 1930.
Central Province Archive of the
Pallottines, Limburg.
Weltkulturen Museum.

77
BUKI AKIB
Kuti Trouser.
FELA A/W 2011.
Photo: Milly Kellner.

78
RAIMUNDO DO VALA WITH HAT AND REVOLVER
Brazil.
Photo: Gustaaf Verswijver, 1975.
Weltkulturen Museum.

79
MAN IN SHORTS, LINEN JACKET AND HAT
Cameroon, West Africa.
Photo: Johannes Lukas, 1952.
Weltkulturen Museum.

80
TERRITORIAL SERGEANT AND HIS WIFE
Banza-Lute, Democratic Republic of Congo, Central Africa.
Photo: Josef Franz Thiel, 1963.
Weltkulturen Museum.

81
DARE AND HIS WIFE KOMBRA IN WEDDING OUTFIT
Madang Province, Papua New Guinea.
Photo: Josef Much, 1938.
Anthropos Institute, St. Augustin.
Weltkulturen Museum.

82
DAUGHTER OF JOHANNES LUKAS AND UNKNOWN MAN
Cameroon, West Africa.
Photo: Johannes Lukas, 1952.
Weltkulturen Museum.

83
YOUNG COUPLE
Lesser Sunda Islands, Indonesia.
Photographer unknown, 1930.
Archive of the Societas Verbi Divini, Steyl.
Weltkulturen Museum.

84
TWO WOMEN
Uganda, East Africa.
Photo: Gert Chesi, 1967.
Weltkulturen Museum.

85
CASSETTEPLAYA
Jermaine Robinson and Carri Munden.
London 2012.
Photo: Michael Quattlebaum.

86
WEDDING IN ST. GEORGEN
St. Georgen, Black Forest, Germany.
Photo: Schöning & Co., Lübeck, undated.
Courtesy Bärbel Grässlin.

87
LOCAL INITIATION RITE AND CIRCUMCISION OF YOUNG MEN
Former Cape Province, South Africa.
Photographer unknown, 1933.
Central Province Archive of the Pallottines, Limburg.
Weltkulturen Museum.

88
(above)
DANZA DE LOS DIABLICOS
(DANCE OF THE DEVIL)
Túcume, Lambayeque, Peru.
Photo: Bernd Schmelz, ca. 1991.
Weltkulturen Museum.

(below)
P.A.M.
Gia Top, Simran Skirt.
POP! Eyes Collection II
S/S 2010.
Photo: Max Doyle.

89
(above)
P.A.M.
High Lands Jacquard Jumper, High Lands Jacquard Beanie, Tranced Lucent Plastic Tee, Duplo Pant.
The High Life A/W 2012.
Photo: Peter Sutherland.

(below)
CHILDREN'S GAME
Yamana, Tierra del Fuego, South America.
Photo: Martin Gusinde, 1918–1924.
Anthropos Institute, St. Augustin.
Weltkulturen Museum.

90
BODY PAINT FOR KEWANIX GAMES
Selk'nam, Tierra del Fuego, South America.
Photo: Martin Gusinde, 1918–1924.
Anthropos Institute, St. Augustin.
Weltkulturen Museum.

91
COSTUME OF THE KLOKETEN SPIRIT
Selk'nam, Tierra del Fuego, South America.
Photo: Martin Gusinde, 1918–1924.
Anthropos Institute, St. Augustin.
Weltkulturen Museum.

92
COSTUME OF THE KINA SPIRIT
Yamana, Tierra del Fuego, South America.
Photo: Martin Gusinde, 1918–1924.
Anthropos Institute, St. Augustin.
Weltkulturen Museum.

93
COSTUME OF THE TANU SPIRIT
Selk'nam, Tierra del Fuego, South America.
Photo: Martin Gusinde, 1918–1924.
Anthropos Institute, St. Augustin.
Weltkulturen Museum.

94
CARNIVAL: DANCE OF THE CHEREQUES
Mexico, 1989.
Photo: Beate Engelbrecht.
Weltkulturen Museum.

COLLECTION 96 – 182

98
MOCCASINS
Collected by H. Lichtenberger before 1862.
Probably Sioux-Santee, Minnesota, USA.
Leather, felt, cotton, glass beads.

99
MOCCASINS
Gift from Robert W. M. A. Lotichius ca. 1934.
Sioux, Great Plains, USA.
Leather, glass beads.

100
MOCCASINS
Purchased from Rosa Schwarzschild.
Probably Sioux, Great Plains, USA.
1890–1900.
Leather, glass beads, sinew.

101
BABY CARRIER
Gift from Rudolf Cronau and J. Schiff 1907.
Sioux Teton-Santee, Great Plains, USA.
Wood, brass, leather, glass beads, cotton.

102
MOCCASINS
Gift from H. von Passavant ca. 1906.
Great Plains, USA.
19th century.
Leather, rawhide, porcupine quills, iron, glass beads, cotton, feathers.

103
MOCCASINS
Purchased from J. F. G. Umlauff ca. 1906.
Probably Sioux, Great Plains, USA.
19th century.
Leather, porcupine quills, glass beads.

104
MOCCASINS
Gift 1990.
Great Plains, USA.
Leather, glass beads.

105
CHILDREN'S BOOTS
Gift from Arthur Max Heinrich Speyer 1933.
Apache, Southwest, USA.
19th century.
Buckskin, glass beads, brass.

106
(above)
SANDALS
Collected by R. Goldschmidt-Rothschild 1910.
Kordofan, Sudan, East Africa.
Leather.

(below)
SANDALS
Collected by Adolf Friedrich Herzog zu Mecklenburg 1910/11.
Shoa Arabs, Cameroon, West Africa.
Wood, leather.

107
WOMEN'S SHOES
(front and back)
Unknown Collector.
China.
Silk.

108
SANDALS
Collected by Siegmund Hess 1864.
Malay, Sumatra, Indonesia.
Wood.

109
SANDALS
Collected by Ernst Vatter, Insulinde Expedition 1928/29.
Lamaholot, Flores, Indonesia.
Lontar palm leaf strips.

110
BAG
Exchanged with Museum für Völkerkunde, Hamburg 1947.
Encounter Bay, South Australia.
String, painted.

111
SANDALS
Collected by Karin Hahn-Hissink and Albert Hahn 1963.
Kuna, San Blas Islands, Panama.
Leather, wool.

112
CHILDREN'S SANDALS
Collected by Johannes Elbert, Frankfurt Sunda Expedition 1909/10.
Sulawesi, Indonesia.
Leaf sheath of sago palm, bamboo, cloth.

113
SANDALS
Collected by Karin Hahn-Hissink and Albert Hahn 1963.
Trique, Oaxaca, Mexico.
20th century.
Sisal.

114 – 115
MEN'S COLLAR
(front and back)
Collected by Achim Sibeth 2009.
Ngadha, Flores, Indonesia.
String, cowries.

116
BELT AND CURRENCY GAUGE
Collected by Eike Haberland, Sepik Expedition 1961.
Chambri, Middle Sepik, New Guinea.
Woven string, shells.

117
MEN'S COLLAR
Collected by Karl Friedrich Wandres before 1907.
Tolai, New Britain, Bismarck Archipelago, Melanesia.
Plant fibres, nassa shells.

118 – 119
(from left to right and top to bottom)

BELT WITH RATTLES
Collected by Lajos Boglár 1988.
Kayapó-Mekragnoti, Amazonia, Brazil.
Palm fibres, cotton, Brazil nuts.

BELT
Purchased from Königliches Zoologisches und Anthropologisch-Ethnografisches Museum, Dresden before 1920.
Yakumul, Northeast Coast, New Guinea.
Bark, painted.

BELT
Collected by Otto H. Zerries and Meinhard Schuster, Frobenius Expedition 1954/55.
Yanomami, Orinoco, Venezuela.
Cotton.

BELT AND CURRENCY GAUGE
Collected by Eike Haberland, Sepik Expedition 1961.
Chambri, Middle Sepik, New Guinea.
String, shells.

120
MEN'S BELT
Collected by Siegfried Seyfarth 1963.
Maramuni-Enga, Central Highlands, New Guinea.
Cuscus tail and claw, conch shells, metal, electric bulb holder, Elastoplast roll.

121
NECKLACE
Purchased from J. F. G. Umlauff 1909.
Maori, New Zealand, Polynesia.
Fibres of New Zealand flax (Phormium tenax).

122
GIRL'S SKIRT
Collected by Hans Sinn before 1968.
Chimbu, Central Highlands, New Guinea.
Bast fibres, cuscus hair.

123
MEN'S APRON
Collected by Siegfried Seyfarth, Sepik Expedition 1963.
Mae-Enga, Central Highlands, New Guinea.
Plant fibres, pig tails.

124
WOMEN'S DANCING SKIRT
Purchased from G. Günther 1976.
Yap, Micronesia.
Hibiscus bast fibres, grass.

125
WOMEN'S SKIRT
Collected by Ruppert 1920–1930.
Northeast Coast, New Guinea.
Plant fibres.

126
NET BAG
Purchased from J. F. G. Umlauff ca. 1905.
Finschhafen, Northeast Coast, New Guinea.
Plant fibres, dog teeth.

127
MEN'S WIG WITH FEATHER DECORATION
Collected by Thomas Michel 1986.
Ialibu, Southern Highlands, New Guinea.
Human hair, bark, leaves, cassowary feathers with skin.

128 – 129
HEAD ORNAMENT FOR HIGH RANKING PERSONS, TUIGA
(front and back)
Collected by Gerda Kroeber-Wolf 1997. Permanent loan from Adolf und Luisa Haeuser-Stiftung zur Kunst und Kulturpflege.
Samoa, Polynesia.
Feathers, bark cloth, shells, coconut fibres, velcro.

130
NET BAG
Purchased from Siegfried Seyfarth 1963.
Maramuni-Enga, Woilep, Central Highlands, New Guinea.
Plant fibres.

131
(left)
NET BAG
Collected by Eva Charlotte Raabe 1999.
Port Moresby, Papua New Guinea.
Cotton.

(right)
NET BAG
Collected by Eva Charlotte Raabe 1980.
Central Highlands, New Guinea.
Plant fibres.

132
NET BAG
Collected by Eva Charlotte Raabe 1999.
Goroka, Eastern Highlands, New Guinea.
Cotton.

133
NET BAG
Collected by Eva Charlotte Raabe 1999.
Goroka, Eastern Highlands, New Guinea.
Cotton.

134 – 135
NET BAG
(front and back)
Collected by Eva Charlotte Raabe 1999.
Port Moresby, Papua New Guinea.
Cotton.

136
NET BAG
Collected by Eva Charlotte Raabe 1999.
Goroka, Eastern Highlands, New Guinea.
Cotton.

137
WOOLLEN HAT
Collected by Mark Münzel 1972.
Quechua, Peru.
20th century.
Wool.

138
LOINCLOTH FOR MARRIED WOMEN
Purchased from Galerie Exler & Co. 1986.
Ndebele, Republic of South Africa.
Leather, glass beads, brass rings.

139
LOINCLOTH FOR YOUNG GIRLS
Purchased from Galerie Exler & Co. 1986.
Ndebele, Republic of South Africa.
Canvas, glass beads.

140
(above)
PURSE
Purchased from Christian Leden 1912.
Inuit, Umanak District, Greenland.
Leather, seal fur.

(below)
PURSE
Gift from Val Bauer 1931.
Maya Tzeltal, San Cristóbal, Mexico.
Leather, plant fibres.

141
SANDALS
Collected by Johannes Elbert, Frankfurt Sunda Expedition 1909/10.
Sulawesi, Indonesia.
Bark, leaf strips.

142 – 143
BACKPACK
(front and back)
Collected by William Beyer 1964.
Ifugao, Luzon, Philippines.
Bamboo, rotang, plant fibres, wood.

144
(from left to right and top to bottom)

PITH HELMET
Collected by Schuricht.
Tagalogs, Luzon, Philippines.
19th century.
Rotang.

HEADDRESS
Collected by Schuricht.
Tagalogs, Luzon, Philippines.
19th century.
Calabash, pandanus fibres, rotang, cotton.

CAP
Purchased from J. F. G. Umlauff 1926.
Bakongo, Democratic Republic of Congo, Central Africa.
Raffia.

HELMET
Purchased from Hessisches Landesmuseum, Darmstadt 1930.
Bugi, Sulawesi, Indonesia.
Before 1866.
Leaf strips, rotang, fibres string, cloth string.

HAT
Collected by Bernhard Hagen 1905.
Bangka, Sumatra, Indonesia.
19th century.
Pandanus leaf fibres.

CAP
Collected by Ernst Prillwitz 1898–1902.
Bugi, Sulawesi, Indonesia.
Orchid leaf fibres.

145
(from left to right and top to bottom)

SIRIH BAG
Purchased from Aalderinck Gallery 1941.
Mandailing Batak, Sumatra, Indonesia.
Leaf strips, glass beads, brass, cotton fabric.

SIRIH BAG
Collected by Wilhelm Volz before 1906.
Alas, Sumatra, Indonesia.
Leaf strips, cotton fabric, gold paper.

SIRIH BAG
Collected by Johanna Agthe 1976.
Karo Batak, Sumatra, Indonesia.
Plastic.

SIRIH BAG
Collected by Wilhelm Volz before 1906.
Alas, Sumatra, Indonesia.
Leaf strips, cotton, gold paper, grain.

146
(above)
HAT FOR INITIATION
Purchased from J. F. G. Umlauff 1920s.
Bougainville, Solomon Islands, Melanesia.
Beginning of the 20th century.
Palm leaves, painted.

(below)
HAT
Collected by Ernst Prillwitz 1898–1902.
Javanese, Java, Indonesia.
Pandanus leaf fibres.

147
(above)
HAT
Exchanged with Museum für Völkerkunde, Hamburg 1947.
Lae-Womba, Huon-Gulf, New Guinea.
Bark cloth, pandanus leaves, possum fur, feathers, painted.

(below)
HELMET
Purchased from J. F. G. Umlauff 1926.
Mbala, Democratic Republic of Congo, Central Africa.
Bast, cowrie shell.

148
(from left to right and top to bottom)

COMB
Collected by Hans Wegmann 1967–2002.
Wai-Wai, Amazonia, Brazil.
Bones, plant fibres, wood, cotton strings, feathers.

COMB
Purchased by Fritz Jaspert 1926/27.
Chokwe, Angola, West Africa.
Wood.

COMB
Collected by August Möckel 1878–1883.
Caroline Islands, Micronesia.
Wood.

COMB
Purchased from William Ockelford Oldmann ca. 1908.
Solomon Islands, Melanesia.
Wood, mother of pearl.

COMB
Purchased from Major von der Hellen 1928.
Seleo, Northeast New Guinea, Melanesia.
Wood, string, nassa shells, dog teeth.

COMB
Exchanged with Rijksmuseum voor Volkenkunde, Leiden 1910.
Ubangi Region, Democratic Republic of Congo, Central Africa.
Rotang.

149
(from left to right and top to bottom)

COMB
Collected by Meinhard Schuster, Sepik Expedition 1961.
Abelam, Ulupu, Aprik, New Guinea.
Wood, netting, feathers, painted.

COMB
Purchased from Moerschell ca. 1908.
Chokwe, Angola, West Africa.
Wood.

COMB
Collected by Hermann Niggemeyer, Frobenius. Expedition to the Moluccas, Dutch New Guinea 1937/38.
Seram, Moluccas, Indonesia.
Bamboo, glass beads, mother of pearl, rotang.

COMB
Purchased from Julius Konietzko 1928.
Admiralty Islands, Bismarck Archipelago, Melanesia.
Wood, painted.

150
(left row from top to bottom)

COMB
Collected by Karin Hahn-Hissink and Albert Hahn, Frobenius Expedition 1952–1954.
Aymara, La Paz, Bolivia.
Bamboo, wood, wool.

COMB
Gift from C. A. Hahn 1903.
Aymara or Quechua, La Paz, Bolivia.
Bamboo, wool.

COMB
Collected by Karin Hahn-Hissink and Albert Hahn, Frobenius Expedition 1952–1954.
Aymara, La Paz, Bolivia.
Bamboo, wood, wool.

COMB
Collected by Karin Hahn-Hissink and Albert Hahn, Frobenius Expedition 1952–1954.
Aymara, La Paz, Bolivia.
Bamboo, wood, wool.

(right row from top to bottom)

COMB
Collected by Mark and Christine Münzel 1989.
Kamayurá, Amazonia, Brazil.
Wood, cotton, vine.

COMB
Collected by Hanni Fiebinger 1980–1984.
Brazil.
Wood sticks, cotton, wire.

151
EARRINGS
(all)
Purchased from Thomas Schunk 1989.
Mali, West Africa.
Gold, cotton thread.

152
EARRINGS
Purchased from L. Exsteens ca. 1910.
Democratic Republic of Congo, Central Africa.
Rotang.

153
EARPLUGS
Collected by Lajos Boglár 1988.
Kayapó-Kubenkrankegn, Amazonia, Brazil.
Mother of pearl, wood sticks, resin, cotton string, feathers.

154
(from left to right and top to bottom)

CHEST ORNAMENT, KAPKAP
Collected by Felix Speiser 1913.
Santa Cruz Islands, Melanesia.
Tridacna, tortoiseshell.

CHEST ORNAMENT, KAPKAP
Collected by Volker Schneider before 1988.
Solomon Islands, Melanesia.
Tridacna, tortoiseshell, plant fibres.

CHEST ORNAMENT, KAPKAP
Collected by Volker Schneider before 1988.
Solomon Islands, Melanesia.
Tridacna, tortoiseshell, plant fibres.

CHEST ORNAMENT, KAPKAP (WITH STRING OF BEADS)
Purchased from Köllecker-Armbruster 1930.
New Ireland, Bismarck Archipelago, Melanesia.
Tridacna, tortoiseshell, beads.

CHEST ORNAMENT, KAPKAP
Collected by Fischer before 1912.
New Ireland, Bismarck Archipelago, Melanesia.
Tridacna, tortoiseshell.

155
(above)
CONTAINER FOR COSMETICS
Collected by R. Flanaus 1904.
Herero, Namibia, South Africa.
Turtle, fur tassel, leather, iron and glass beads.

(below)
CONTAINER FOR COSMETICS
Purchased from von Zwergern before 1911.
Herero, Namibia, South Africa.
Turtle, fur tassel, leather, iron and glass beads.

156
COMB
Collected by Alfred Bühler before 1950.
Exchanged with Museum für Völkerkunde (Museum der Kulturen), Basel 1951.
Sumbanese, Sumba, Indonesia.
Tortoiseshell.

157
COMB
Collected by Wilhelm Müller-Wismar 1913/14.
Exchanged with Rautenstrauch-Joest-Museum, Köln 1938.
Tanimbar Islands, Moluccas, Indonesia.
Wood, bone.

158
HAIRSLIDE
Collected by Christian F. Feest and Sylvia S. Kasprycki 2001.
Mohawk, Akwesasne Reservation, New York, USA.
Glass beads, artificial leather, metal.

159
COMB
Collected by Gerda Kroeber-Wolf 1997. Permanent loan from Adolf und Luisa Haeuser-Stiftung zur Kunst und Kulturpflege.
Samoa, Polynesia.
Coconut shell.

160
NAIL JEWELLERY
Collected by Johanna Agthe 1979.
Sumatra, Indonesia.
Brass, copper, iron.

161
(above)
EAR JEWELLERY
Collected by Ernst Prillwitz 1898–1902.
Javanese, Java, Indonesia.
Brass plate.

(below)
HAIR PIN
Collected by Ernst Prillwitz 1898–1902.
Javanese, Java, Indonesia.
Brass plate, rhinestone.

162
(from left to right and top to bottom)

PENIS CAP
Collected by Karl Friedrich Wandres before 1907.
Vanimo, Northeast New Guinea.
Coconut shell.

PENIS SHEATH
Collected by Lajos Boglár 1988.
Kayapó, Amazonia, Brazil.
Palm leaves.

PENIS COVER
Collected by Thomas Michel 1986.
Eipo, Highlands, West New Guinea.
Gourd, plant fibres.

PENIS COVER
Collected on Sepik Expedition 1961.
Kupkain, Upper Sepik, New Guinea, Melanesia.
Basketry.

163
(from left to right and top
to bottom)

PENIS CAP
Purchased from J. F. G.
Umlauff ca. 1905.
Northeast New Guinea.
Early 20th century.
Pericarp.

PENIS ADORNMENT
Collected by Meinhard Schuster,
Sepik Expedition 1961.
Kubungai, Middle Sepik,
New Guinea.
Plant fibres, nassa shells,
glass rings.

PENIS CAP
Collected by Eike Haberland,
Sepik Expedition 1961.
Kupkain, Upper Sepik,
New Guinea.
Nuts, basketry, nassa shells.

PENIS COVER
Collected by Thomas Michel
1986.
Nalumin, Star Mountains,
New Guinea.
Gourd, plant fibres.

PENIS COVER
Collected by Thomas Michel
1986.
Nalumin, Star Mountains,
New Guinea.
Gourd, plant fibres.

164
(left row, first three objects)
LOINCLOTH FOR WOMEN
Purchased from Guillaume
Dehondt 1927.
Mangbetu, Democratic Republic
of Congo, Central Africa.
Palm leaves, bast lace.

(left row, last object and
right row)
LOINCLOTH FOR WOMEN
Gift from Hermann Schubotz
1910/11.
Mangbetu, Democratic Republic
of Congo, Central Africa.
Palm leaves, bast lace.

165
(from left to right and top
to bottom)

HAT
Collected by G. A. Regner
before 1904.
Malinke, Liberia, West Africa.
Plant fibres.

HAT
Collected by Reinhold
Th. Rhode 1904.
Anyang, Cameroon,
West Africa.
Palm tree leaves, leather.

HAT
Collected by Hermann Schubotz
1910/11.
Mangbetu, Democratic Republic
of Congo, Central Africa.
Rotang.

HAT
Gift from Adolf Friedrich
Herzog zu Mecklenburg
1910/11.
Babangi, Ubangi Region,
Democratic Republic of Congo,
Central Africa.
Rotang, pandanus, cotton,
feathers.

HAT
Gift from Karl Rehorn 1895.
Sotho, Baralong District,
former Orange Free State,
Republic of South Africa.
Grass.

CAP
Collected by Johannes Elbert,
Frankfurt Sunda Expedition
1909/10.
Bugi, Sulawesi, Indonesia.
Rotang, leaves, plant stems.

166 – 167
MEN'S HAT
(inside view and view from
above)
Collected by August Möckel
before 1932.
Tagalogs, Luzon, Philippines.
19th century.
Leaf strips, rotang, cotton,
string.

168
MEN'S HAT
Collected by Julius Konietzko
1928/29.
Kalamba, Democratic Republic
of Congo, Central Africa.
Cotton, raffia.

169
MEN'S HAT
Collected by Julius Konietzko
1928/29.
Kalamba, Democratic Republic
of Congo, Central Africa.
Cotton, raffia.

170
PRIEST'S HAT
Collected during the "23.
Deutsche Inner-Afrikanische
Forschungsexpedition"
to Ethiopia 1950 – 1952.
Amhara, Ethiopia, East Africa.
Cotton, felt.

171
DIGNITARY'S HAT
Collected by Otto Sprunck.
Gift from Wolfgang Giere 2008.
Ethnic group and region
unknown.
Cotton.

172
DIGNITARY'S HAT
Collected by Otto Sprunck.
Gift from Wolfgang Giere 2008.
Ethnic group and region
unknown.
Cotton, wood.

173
DIGNITARY'S HAT
Collected by Reinhold
Th. Rohde 1904.
Tikar, Cameroonian Grassland,
West Africa.
Cotton, raffia.

174
MASK
Collected by Frobenius
Association.
Chewa, Salima, Malawi,
East Africa.
Strips of textile, felt,
cotton, bast.

175
MASK
Collected by Frobenius
Association.
Chewa, Salima, Malawi,
East Africa.
Textile, silver paper, feathers,
fur, gauze straps.

176
BRIDAL HEADDRESS
Collected by Eike Haberland,
Sepik Expedition 1961.
Iatmul, Middle Sepik,
Papua New Guinea.
À-jour knit, nassa shells.

177
BRIDAL HEADDRESS
Collected by Eike Haberland,
Sepik Expedition 1961.
Sawos, Middle Sepik,
Papua New Guinea.
À-jour knit, nassa shells.

178
HAT FOR THE HUNTING
GOD OXÓSSI
Part of a ritual costume ensemble,
made by Gilmar Tavares and
Doté Amilton Costa.
Acquired by Erica Jane de
Hohenstein and Mona Suhrbier
2008.
Salvador da Bahia, Brazil.
Sheet brass, tin-lead solder,
plastic fibres, varnish.

179
BRIDAL CROWN
Collection Bärbel Grässlin,
date unknown.
Black Forest, Germany.
Glass, plastic, textile, wire.

180
(above)
FEATHER HEADDRESS
Collected by Lajos Boglár
before 1988.
Kayapó-Xikrin, Amazonia,
Brazil.
Cotton, feathers.

(below)
FEATHER HEADDRESS
Collected by Mark and Christine
Münzel 1989.
Kamayurá, Amazonia, Brazil.
Palm leaves, feathers.

181
(above)
FEATHER HEADDRESS
Gift from Jose Lacerda de
Aranjo Feio before 1972.
Kamayurá, Amazonia, Brazil.
Cotton, feathers.

(below)
FEATHER HEADDRESS
Collected by Lajos Boglár before 1988.
Kayapó-Mekragnoti,
Amazonia, Brazil.
Cotton, feathers.

182
LIP PLUG
Purchased from Johannes Flemming 1926.
Guaraní Chiriguano,
Gran Chaco, Bolivia.
Tin, glass beads.

COLLECTION OF THE COLLECTION 184 - 238

190
BUKI AKIB

191
BUKI AKIB
Fela Jacket.
FELA A/W 2011.
Photo: Milly Kellner.

192 - 193
ASSEMBLAGE, BUKI AKIB
Weltkulturen Labor 2012.

(from left to right and top to bottom)

ANKLE RATTLE
Collected by Bernhard Struck 1933.
Pepel, Guinea-Bissau,
West Africa.
Pericarp, plant fibres.

ANKLE RATTLE
Collected by Hans Himmelheber 1930.
Gouro, Ivory Coast,
West Africa.
Palm leaves, plant fibres.

RATTLE
Collected by Forschungsinstitut für Kulturmorphologie, undated.
Bata, Cameroon, West Africa.
Pericarp, wood sticks, cotton.

RATTLE
Collected by Ambrosius Mayer, undated.
Ngingo, Matumbi Mountains,
Tanzania, East Africa.
Wood, skin, plant fibres.

194 - 195
PROTOTYPE DESIGN,
BUKI AKIB
Weltkulturen Labor 2012.

196 - 197
STUDIO, BUKI AKIB
Weltkulturen Labor 2012.

198 - 199
BUKI AKIB
Weltkulturen Labor 2012.

200 - 203
PROTOTYPE DESIGN,
BUKI AKIB
Weltkulturen Labor 2012.

204
A KIND OF GUISE

205
A KIND OF GUISE
Harlekin Blazer, Stitched Pattern Shirt, Harlekin Pants, Behave Blazer, Behave Pants.
The Carpathian Season A/W 2012.
Photo: A Kind of Guise.

206 - 207
INSTALLATION,
A KIND OF GUISE
Weltkulturen Labor 2012.

208 - 209
ASSEMBLAGE,
A KIND OF GUISE
Weltkulturen Labor 2012.

MASKS
Collected by Ernst Prillwitz before 1902 and by van Lier 1941.
Javanese, Java, Indonesia.
Wood.

210
PROTOTYPE DESIGN,
A KIND OF GUISE
Weltkulturen Labor 2012.

211
STUDIO,
A KIND OF GUISE
Weltkulturen Labor 2012.

212 - 213
STUDIO,
A KIND OF GUISE
Weltkulturen Labor 2012.

214
CARNIVAL: DANCE OF THE CHEREQUES.
Mexico, 1989.
Photo: Beate Engelbrecht.
Weltkulturen Museum.

215
PROTOTYPE DESIGN,
A KIND OF GUISE
Weltkulturen Labor 2012.

216
ASSEMBLAGE,
A KIND OF GUISE
Weltkulturen Labor 2012.

MASK
Collected by W. Carl.
Sulka, Gazelle Peninsula,
New Britain, Melanesia.
Wood, basketry.

217
PROTOTYPE DESIGN,
A KIND OF GUISE
Weltkulturen Labor 2012.

218
CASSETTEPLAYA

219
CASSETTEPLAYA
Kadeem + Kyrone Oak,
E5 London 2012.
Quilted Digital Print Jacket, Shorts, Digital Print Trousers, Screen Printed Tee Shirt.
Carni Cannibal Palace A/W 2012/13.
Photo: Alis Pelleschi.

220 - 221
INSTALLATION,
CASSETTEPLAYA
Weltkulturen Labor 2012.

222
(above)
CARRI MUNDEN,
CASSETTEPLAYA
Weltkulturen Labor 2012.

(below)
ASSEMBLAGE,
CASSETTEPLAYA
Weltkulturen Labor 2012.

CANOE PROW, TAUIHU
Purchased from M. L. J. Lemaire, 1950s.
Maori, New Zealand, Polynesia.
Wood.

223
ASSEMBLAGE,
CASSETTEPLAYA
Weltkulturen Labor 2012.

(above)
BRIDAL HEADDRESSES
Collected by Eike Haberland,
Sepik Expedition 1961.
Sawos and Iatmul, Middle Sepik, Papua New Guinea.
À-jour knit, nassa shells.

SCULPTURE
Collected by Eike Haberland,
Sepik Expedition 1961.
Iatmul, Middle Sepik, Papua
New Guinea.
Wood.

(below)
LOINCLOTH FOR WOMEN
Purchased from Galerie
Exler & Co. 1986.
Ndebele, Republic of
South Africa.
Textile, glass beads.

224 - 225
STUDIO,
CASSETTEPLAYA
Weltkulturen Labor 2012.

226
ASSEMBLAGE,
CASSETTEPLAYA
Weltkulturen Labor 2012.

SUSPENSION HOOK
Collected by Eike Haberland,
Sepik Expedition 1961.
Iatmul, Middle Sepik, Papua
New Guinea.
Wood, human hair, nassa
shells.

227
PROTOTYPE DESIGN,
CASSETTEPLAYA
Weltkulturen Labor 2012.

228 - 229
FILM STILL FROM
IATMUL (NEW GUINEA,
MIDDLE SEPIK) -
INITIATION OF MEN AT
JAPANAUT: "DEATH OF
THE NOVICES"
Hermann Schlenker, 1973.
IWF (Institut für den wissen-
schaftlichen Film), Göttingen.
Weltkulturen Museum.

230 - 231
FILM STILL FROM
"BLOOD RITES"
CASSETTEPLAYA, 2012.
Director: Santiago Arbelaez.
Art Director: Carri Munden.
Body Art: Bea Sweet.

232
P.A.M.

233
P.A.M.
Tempo Top, Goude Trouser,
Deep Echo Long Sleeve Top,
Vibrations Leggings, Rousseau
Sandals.
Deep Forest Remix A/W 2012.
Photo: Max Doyle.

234
ASSEMBLAGE, P.A.M.
Weltkulturen Labor 2012.

(left)
MASK, PARROT
Purchased by Johannes
Flemming 1928.
Tikuna, Amazonia, Brazil.
Bark cloth, wood.

(right)
MASK, MONKEY
Unknown collector.
Tikuna, Amazonia, Brazil.
Bark cloth, wood, resin,
glass mirror.

235
STUDIO, MISHA
HOLLENBACH AND
SHAUNA TOOHEY
(P.A.M.)
Weltkulturen Labor 2012.

236
ASSEMBLAGE, P.A.M.
Weltkulturen Labor 2012.

(from left to right)

WIG
Purchased from Höllerer 1906.
Finschhafen, Northeast Coast,
New Guinea.
Human hair.

AXE FOR DANCING
CEREMONIES
Collected by Volker Schneider
1980s.
Tolai, Duke of York Islands,
Bismarck Archipelago,
Melanesia.
Wood, plant fibres, painted.

ROOF DECORATION
Collected by Volker Schneider
1980s.
Tolai, Duke of York Islands,
Bismarck Archipelago,
Melanesia.
Wood, plant fibres, feathers,
ginger leaves.

ORNAMENT FOR
TUBUAN BOATS
Collected by Volker Schneider
1980s.
Tolai, Duke of York Islands,
Bismarck Archipelago,
Melanesia.
Wood, feathers.

ROOF DECORATION
Collected by Volker Schneider
1980s.
Tolai, Duke of York Islands,
Bismarck Archipelago,
Melanesia.
Wood, feathers, painted.

HAT ORNAMENT
Collected by Volker Schneider
1980s.
Tolai, Duke of York Islands,
Bismarck Archipelago,
Melanesia.
Wood, feathers, painted.

ROOF DECORATION
Collected by Volker Schneider
1980s.
Tolai, Duke of York Islands,
Bismarck Archipelago,
Melanesia.
Wood, plant fibres, feathers,
painted.

237
ASSEMBLAGE, P.A.M.
Weltkulturen Labor 2012.

(top row)
MASKS OF MALE SPIRIT
ANHANG'Ú AND FEMALE
SPIRIT ANA'U
Collected by Mark and Christine
Münzel 1967/68.
Kamayurá, Upper Xingu,
Amazonia, Brazil.
Gourd, palm fibres, painted.

(bottom, from left to right)

CEREMONIAL DIGGING
STICK
Collected by Mark and Christine
Münzel 1989.
Kamayurá, Upper Xingu,
Amazonia, Brazil.
Wood, painted.

BIRD SHAPED STOOL
Collected by Mark and Christine
Münzel 1968.
Kamayurá, Upper Xingu,
Amazonia, Brazil.
Wood, mother of pearl, painted.

SACRIFICIAL YAM
Collected by Erica Jane de
Hohenstein 1992/93.
Salvador da Bahia, Brazil.
Fibreglass, painted.

BIRD SHAPED STOOL
Collected by Mark and Christine
Münzel 1968.
Kamayurá, Upper Xingu,
Amazonia, Brazil.
Wood, mother of pearl, painted.

SANDALS
Purchased from the Museum
für Völkerkunde, Berlin 1921.
Somali, Somalia, East Africa.
Leather.

238 - 239
STUDIO, P.A.M.
Weltkulturen Labor 2012.

240 - 241
PROTOTYPE DESIGN,
P.A.M.
Silk screen on paper.
Weltkulturen Labor 2012.

242 - 243
PROTOTYPE DESIGN,
P.A.M.
Clay Masks.
Weltkulturen Labor 2012.

244
ASSEMBLAGE, P.A.M.
Weltkulturen Labor 2012.

(above)
PANTS
Collected by A. Mischlich 1965.
Hausa, Togo, West Africa.
Cotton.

(below)
SMOCK, TOBE
Collected by Schneider 1913.
Hausa, Togo, West Africa.
Cotton.

245
P.A.M.
Weltkulturen Labor 2012.

246 - 249
PROTOTYPE DESIGN,
P.A.M.
Weltkulturen Labor 2012.

WELTKULTUREN MUSEUM

ambiente arte BRITISH COUNCIL THEATRUM MUNDI / GLOBAL STREET

hessische kultur stiftung STADT FRANKFURT AM MAIN MUSEUMSUFERFRANKFURT

WELTKULTUREN MUSEUM
Ein Museum der Stadt
Frankfurt am Main

Schaumainkai 29–37
60594 Frankfurt am Main
Tel.: +49(0)69 212 45115
www.weltkulturenmuseum.de

DIRECTOR
DR. CLÉMENTINE DELISS

ASSISTANT TO THE DIRECTOR
ANNE MARIE BUENKER

RESEARCH CURATOR AFRICA
YVETTE MUTUMBA

RESEARCH CURATORS AMERICAS
DR. MONA SUHRBIER
NIKOLA KLEIN

RESEARCH CURATOR OCEANIA
DR. EVA CH. RAABE

RESEARCH CURATOR SOUTHEAST ASIA
VANESSA VON GLISZCZYNSKI

IMAGE AND FILM ARCHIVIST
ALICE PAWLIK

RESTORERS
WOLFGANG KREBS
SABINE LORENZ

HEAD OF EDUCATION
STEPHANIE ENDTER

LIBRARIANS
RENATE LINDNER
MARIA REITH-DEIGERT

PRESS AND PUBLIC RELATIONS
MEIKE WEBER
JULIA RAJKOVIC-KAMARA

Teimaz Shahverdi would like to thank Leila & Roya Arab, David Ardinast, Paul Bauer, Alexander Burkart, Tobias Friedberg, Mitra Ghaznavi, Hannes Grassegger, Oliver Heinzenberger, Leonard Kahlcke, Sanaz & Edouard Lange, Badia Ouahi, Tobias Rehberger, Shahram Shahverdi and Mengistu Zeleke.

EXHIBITION
TRADING STYLE –
Weltmode im Dialog
08.11.2012 – 31.08.2013

WITH
BUKI AKIB
A KIND OF GUISE
CASETTEPLAYA
P.A.M.

ARTISTIC DIRECTOR
TEIMAZ SHAHVERDI

PROJECT COORDINATOR
CHRISTINE PETERS

CURATORIAL ASSISTANT
NINA HUBER

ASSISTANTS
FRIEDERIKE HAGEL
PAULA KNORR

MUSEUM DESIGN
MATHIS ESTERHAZY
BAUSPRACHE, VIENNA

EXHIBITION TECHNOLOGY
BERND VOSSMERBÄUMER
THOMAS WEISER
THORSTEN VIERHOCK

THEATRUM MUNDI / GLOBAL STREET
TRADING STYLE – Weltmode im Dialog is part of Theatrum Mundi / Global Street, a research project directed by Richard Sennett and Saskia Sassen based in Frankfurt, London and New York.
www.theatrum-mundi.org

The Weltkulturen Museum would like to thank Bärbel Grässlin and the Grässlin family for kindly lending their Black Forest hats for the exhibition. We would also like to thank the Anthropos Institute, the Archive of the Jesuits, the Archive of the Societas Verbi Divini, the Central Province Archive of the Pallottines, Georg-Christof Bertsch, Gert Chesi, Alex Düsterberg, Alex Hidalgo, Reinhard Klimmt, Frank Landau, Hubert Machnik, Museum LA8, Christopher Pfeffer, Saskia Sassen, Michael Satter, Hermann Schlenker, Nähmaschinen Schmid, Richard Sennett, Josef Franz Thiel, Christian Zickler and Julia Ziegler.

PUBLICATION
Published to accompany the exhibition TRADING STYLE – Weltmode im Dialog at the Weltkulturen Museum, Frankfurt am Main from 08.11.2012 – 31.08.2013.
www.weltkulturenmuseum.de

EDITORS
DR. CLÉMENTINE DELISS
TEIMAZ SHAHVERDI

EDITORIAL ASSISTANTS
NINA HUBER
ALICE PAWLIK

PHOTOGRAPHY
WOLFGANG GÜNZEL

DESIGN
VERY, FRANKFURT A.M.

PROOFREADER
CORNELIA SOPHIE MOELLER

TRANSLATION
PETRA GAINES

PROJECT MANAGEMENT KERBER VERLAG
MARTINA KUPIAK

The Deutsche Nationalbibliothek lists this publication in the Deutsche Nationalbibliografie; detailed bibliographic data are available on the Internet at http://dnb.d-nb.de.

PRINTED AND PUBLISHED BY
Kerber Verlag, Bielefeld
Windelsbleicher Str. 166–170
33659 Bielefeld, Germany
Tel. +49(0)521/95008-10
Fax +49(0)521/95008-88
info@kerberverlag.com
www.kerberverlag.com

Kerber, US Distribution D.A.P.,
Distributed Art Publishers, Inc
155 Sixth Avenue, 2nd Floor
New York, NY 10013
Tel. +12126271999
Fax +12126279484

Kerber publications are available in selected bookstores and museum shops worldwide (distributed in Europe, Asia, South and North America).

All rights reserved. No part of this publication may be reproduced, translated, stored in a retrieval system or transmitted in any form by any means, electronic, mechanical, photocopying or recording or otherwise, without prior permission of the publisher.

The rights to use the illustrations found in this catalogue were granted by the owners/rights holders cited in the legends (see index) or were taken from our archives. It was not possible to determine the rights holders in all cases. Justified claims will be compensated within the framework of the usual agreements.

This publication is supported by the Hessische Kulturstiftung.

© 2013 Kerber Verlag, Bielefeld/Berlin, the Artists and Authors, Weltkulturen Museum.

ISBN 978-3-86678-774-2
PRINTED IN GERMANY